THE EDWARDIAN EYE OF
ANDREW PITCAIRN-KNOWLES
(1871–1956)

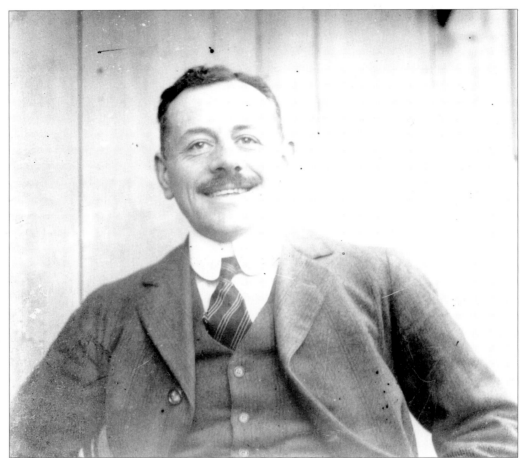
Self portrait of Andrew Pitcairn-Knowles, around 1910

THE EDWARDIAN EYE OF
ANDREW PITCAIRN-KNOWLES
(1871–1956)

Richard Pitcairn-Knowles

The Book Guild Ltd
Sussex, England

The Book Guild Ltd
25 High Street
Lewes, Sussex

First Published 2000
© Richard Pitcairn-Knowles

Set in Garamond

Origination, printing and binding in Singapore
under the supervision of
MRM Graphics Ltd, Winslow, Bucks

A catalogue record for this book is
available from the British Library

ISBN I 85776 427 7

CONTENTS

DEDICATION

Into the new millennium come the great, great grandchildren of Andrew Pitcairn-Knowles; to date, five: Lucy, Ben, Ellen, Amelia, and Polly. This book is dedicated to them, and any additional brothers, sisters or cousins yet to arrive; may they expand the creative and healing works started by their ancestors over a century ago, and continued by the three intervening generations as naturopath, osteopaths, occupational therapist, speech therapist and fitness instructor!

FOREWORD

by
Mark Haworth-Booth
Curator of Photographs
Victoria and Albert Museum, London

I have followed the career of Andrew Pitcairn-Knowles for over twenty-five years – his posthumous one, that is. In the 1960s Richard Pitcairn-Knowles found himself the surprised inheritor of many glass negatives. The boxes of *Plaques Instanées* or *Extra Rapides* were inscribed in his grandfather's hand: Cider, Derby, Violet Farm, Paris Animal Market, etc. It is one thing to have a vague proud awareness of your grandfather as a pioneering Edwardian photographer – one of the first wave of photojournalists – but quite another to organise an attic-full of plates, prints and old magazines. The first revival of this remarkable career came in 1973 at The Photographers' Gallery in London. The gallery was then only two years old but already fulfilling its aim of providing neglected photographers, past and present, with a central exhibition venue. D.B. Tubbs had new prints made from the old negatives and they looked superb. Two years later, I saw selected images by Pitcairn-Knowles once again, this time in the exhibition *The Real Thing: an Anthology of British Photographs 1840-1950*, shown at the Hayward Gallery on London's South Bank. The rediscovery of Andrew Pitcairn-Knowles was part of a larger reassessment, as the whole project of photography came to be analysed and repositioned within our culture. We might think that photography has found its place at last - that the recent opening of the Canon Photography Gallery at the V&A, for example, means that some 'canon' of great photographers has finally been established and that everything of significance that can be known has been published. Not so, of course, which is why I welcome this book with enthusiasm.

The book brings into view one of the most engaging, but previously unfamiliar, little masters of photography in modern times. The text, a compilation by a family historian and a journalist, is written with knowledge and skill. It contains

a wealth of new data about the origins of modern photojournalism and that new and compelling figure, the photojournalist. The story also features – as the reader will discover – an extraordinarily neat, elegant, use of literature to illuminate photographic history. I will say no more, other than that it involves the Great Sleuth himself, Mr Sherlock Holmes. It will not spoil the pleasure in store if I add that the passage in question deftly reminds us of something we surely already know: that although the camera is simply a drawing-machine, much of the personality of its operator may be deduced from the resulting photographic images. As we look at the plates in this book, we make the acquaintance of a man who was willing to take great pains over apparently small things… someone who invested imaginative involvement in the accurate portrayal of unremarkable pastimes and humble livelihoods. He gave these pictures technical knowledge in abundance but also the priceless quality of concentrated, absorbed attention. The sense of timing, drama, human nature and geometry demanded by this kind of photography can require considerable reserves of nervous energy. (This photographer, after all, defied the laws of entertainment by constantly working with small children and animals). Thus, like many other remarkable photographers, APK's career in the medium was short. He moved on to another life altogether. However, his time in photography will go on making him posthumous friends, as later generations discover an Edwardian eye which saw the world with gusto, hilarity, humility and grace.

THANKS

I am so very grateful to so many people who have encouraged me to publish Andrew Pitcairn-Knowles' work. It has taken over twenty-five years and would not have happened if it had not been for the lucky curiosity, back in the early 1970's, shown by Gordon Anckorn, photographer with the *Sevenoaks Chronicle* for many years.

The major contribution came from D.B. (Bunny) Tubbs, motoring journalist and motorcar historian who, sadly, died aged 86 only a few months before publication. When he saw the motor racing plates his enthusiasm was fired, and his research and subsequent writings form so much of the material. Without him this book would most certainly not have been published. The lives of Andrew Pitcairn-Knowles and Bunny Tubbs overlapped by many years but they never met. They would have been able to express what surely would have been mutual admiration had their paths crossed.

Most grateful thanks must be expressed also for the skills of John Maltby, sadly also now deceased, who was photographer and assessor on the nominations board for candidates at the Institute of Incorporated Photographers, for the fine prints he made from the glass negatives; the information from Edward Holmes, author of *The Age of Cameras*; the dedication of Sue Davies, then director of the Photographers' Gallery, Great Newport Street, who put on the first exhibition, *Pre 1914 Reportage from Europe*, which went on tour throughout Britain; the broad inclusiveness of Ian Jeffrey, who included twelve APK prints in The Arts Council exhibition, *The Real Thing - An Anthology of British Photographs 1840-1950*, at the Hayward Gallery; the help by Mark Haworth-Booth, Curator of Photographs at the Victoria and Albert Museum who used two of APK's original prints in the V&A exhibition, *A Guide to Early Photographic Processes*, and who has kindly written the Foreword to this book; advice from Dr. Heiner Gillmeister the German sports historian of Bonn University; the patience of my wife, Pamela, for putting up with the extraordinary bulkiness of the material strewn about the house from time to time, and for proof reading.

Had it not been for all of the above, and many more whose encouragement and help should be mentioned, APK would have faded into oblivion. So many other individuals urged publication but no single publisher could see a commercial production in the work. So, finally go thanks to Carol Biss and the staff at The Book Guild for this "non-commercial in the name of photographic history" publication!

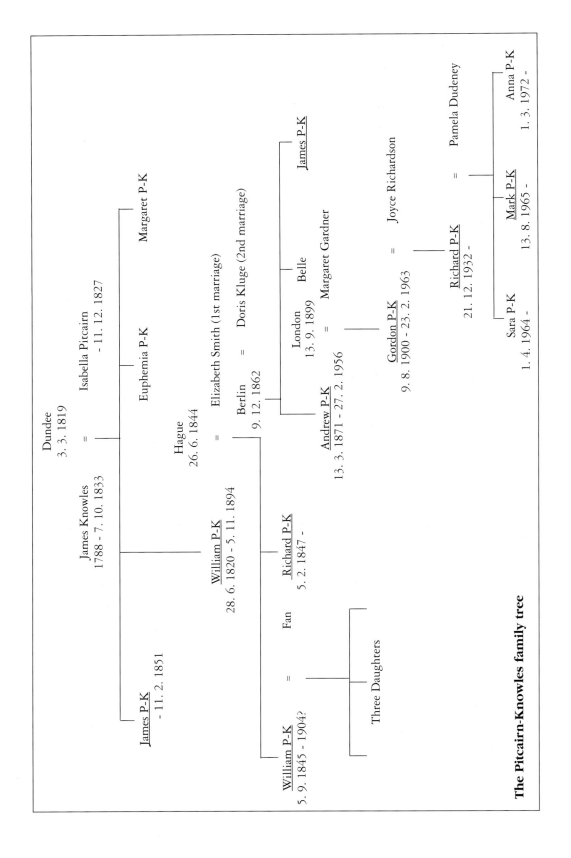

The Pitcairn-Knowles family tree

THE LIFE OF ANDREW PITCAIRN-KNOWLES (1871–1956)

This book is primarily a presentation of photographs taken by Andrew Pitcairn-Knowles during that part of his life, the prime years between 30 and 40, when he travelled Europe in search of stories just waiting to be photographed.

Andrew Pitcairn-Knowles was truly a man ahead of his time. Founder and editor of sports magazines in Germany in the last decade of the 19th century and founder of sports clubs in Germany, Belgium and France around 1900, pioneer European photojournalist in the first decade of the 20th century, and later founder of complementary medicine in England in 1912, he was helped in his achievements by being fluent in both German and French.

Before we study his photographs we will take a brief look at his ancestors and then some 'snapshots' of his first 30 years, leading up to the photographic period of his life.

Andrew Pitcairn-Knowles inherited his hyphen from his grandfather, James Knowles (1788–1833), and his grandmother, Isabella Pitcairn, who linked their names when they married at Dundee in 1819. The name remained rare, there having been a mere nine Pitcairn-Knowles male offspring over the last 180 years, of whom only four have sired sons!

After the marriage James and Isabella left for Holland to found a family and a woollen business which prospered over the years. The marriage of only 14 years was brought to a sudden end when, on a visit home to Scotland in 1833, James died, the first recorded victim of cholera in Edinburgh, leaving his widow and four children. It was his 13-year-old son, William, who carried on the business in due course, most prosperously. William also built up a well known porcelain and pottery collection, and was eventually persuaded by friends to

1

write a book, *Dutch Porcelain and Pottery*, published by Newnes, and referred to by experts even now.

William Pitcairn-Knowles was first married at 24 to his cousin, Elizabeth Smith, on 26th June 1844 at the British Embassy in the Hague, and they had two sons, the first christened after his father. This William, according to the *Dictionary of Victorian Painters,* was a landscape painter, active from 1882–92, who exhibited five works at the Royal Society of British Artists. He married Fanny Campbell, the daughter of the American Consul in Rotterdam, and they had three daughters, one of whom, Josephine, wrote *The Upholstered Cage,* a suffragette movement book published by Hodder and Stoughton in 1912. The notice of William senior's first marriage appeared in the *Edinburgh Evening Courant* next to a report entitled 'THE SHIP SALADIN - Mutiny and Horrible Murders on the High Seas'!

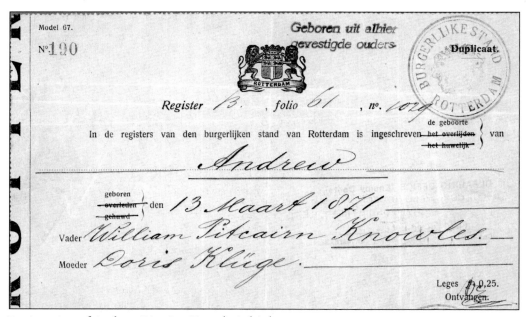

Registration of Andrew Pitcairn-Knowles's birth

Of more concern to us is the second marriage in Berlin in 1862 to Andrew's mother, Doris Klüge, a Polish opera singer. There was no ominous report of murder beside the notice of this marriage in the *Rotterdamsche Courant* of 9th December, and it was to last 32 years and produce three children, James, Belle, and Andrew.

Andrew's artistic and creative family and cosmopolitan background – Scottish father, Polish mother, and his birth in Rotterdam – heralded an interesting, if

restless, life of travel and changing occupations. He was born on 13th March 1871 and spent the early part of his life in Rotterdam until his father retired and the family decided, like many prosperous Britons of their day, that money would go further and life would be more fun on the Continent than at, say, Cheltenham or Tunbridge Wells. Flourishing 'English Colonies' existed in Nice, Florence, Bologna, Aix-les-Bains and other places, complete with English church and lending library. Then, of course, there were the German principalities. What better place for German speakers than Wiesbaden, where the palace of the dukes of Nassau was now lived in by the Emperor himself? Beautifully situated on the Rhine with the Taunus mountains behind and vineyards all about, the town supported a casino, several theatres and an opera house of high repute, which must have endeared it to Mrs Pitcairn-Knowles.

Soon the family was established in a large villa in the fashionable part of this spacious provincial capital, in Sonnenberger Strasse 30 where Mrs Pitcairn-Knowles held her salon and all found a place amid the combined sparkle and stuffiness of German court life. The business in Rotterdam had been sold and in 1877 the family estate of Kirkville near Aberdeen, which had been let for a number of years, was also sold. At this point in their history the Pitcairn-Knowles family could be described as wealthy. The boys, James and Andrew, occupied a flat on the top floor of the house, with a valet to themselves and private tutors until James went off to study painting.

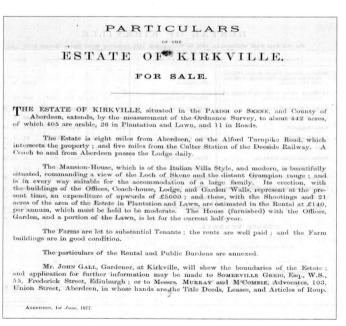

The sale of the Pitcairn-Knowles estate at Kirkville

3

Brought up among the heel-clicking Prussian nobility, Andrew must have found it quite natural that his father intended him to join the British army, where life could be fun for young officers with private means who also happened to be good at games. Pitcairn-Knowles loved tennis, hockey and football and was thoroughly at home on skates. Accordingly in July 1889 he entered the Royal Military Academy, Sandhurst, doing reasonably well in the entrance exam. His marks for Composition (58%) were not bad, while his German paper was brilliant, a resounding 96.4%. Soon, however, he realised that army life was not for him. He left the Academy and returned to Germany, although not to a life of leisure. He enrolled at the University of Freiburg-im-Breisgau to study science, with special emphasis on chemistry. He matriculated in chemistry in the winter term 1892/93 and attended the Lehranstalf für Photographie und Reproduktionsverfuhren in Vienna in the winter term 1894/95.

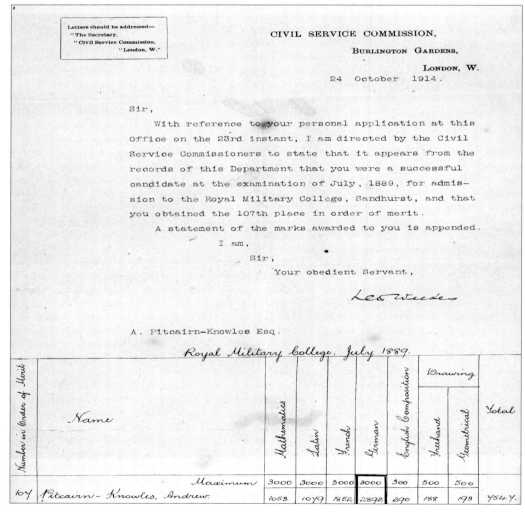

The results of PK's entrance exam to the Royal Military College, Sandhurst

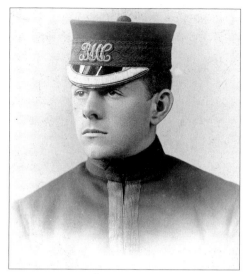

PK in RMC uniform

At what age Andrew began taking pictures we do not know; but the big Wiesbaden house must have had plenty of space for a dark room and there was tremendous interest in amateur photography during his boyhood. Photographically there has never been a more exciting period. The slow, messy and romantic Scott-Archer process, in which glass plates had to be coated with liquid collodion on site, sensitised in the dark and exposed while still wet, was giving way to much hardier dry plates, which could be bought ready coated, and used at leisure. By 1878, after seven years of experiment (which coincided with the first seven years of Andrew's existence), readymade gelatine-silver-bromide dry plates were being advertised for sale in England by two firms, Wratten & Wainwright, and the Liverpool Dry-Plate Company. Manufacture in Germany quickly followed

and a host of simple inexpensive cameras came out, catering for the amateur market. The illustration shows the later boxes of French-manufactured Plaques Extra Rapides Au Gelatino-Bromure d'Argent used by Pitcairn-Knowles in which his developed plates, carefully labelled, were stored for the next 60 years.

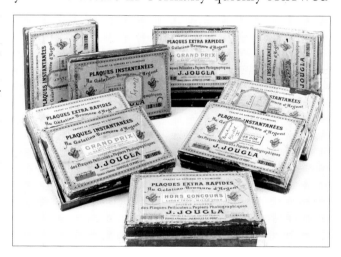

During his boyhood, Pitcairn-Knowles (or PK, as we shall call him from now on, because he was always known by these initials) can hardly have escaped the craze for 'detective' cameras which swept Europe during the 1880s. Fitted with 'instantaneous' shutter and disguised as brown paper parcel or Gladstone bag, these instruments could be used without the subject's knowledge. Among professional users was the famous Paul Martin, whose studies of street traders may well have inspired PK's own later work. Still greater scope for action

photography came in the late 1880s when the Prussian naturalist Ottomar Anschutz, with the help of Carl Paul Goerz, developed the focal plane shutter allowing exposures as short as 1/1000 second for studying birds in flight. Then, before PK went to Sandhurst, Abbe and Schott, working with Carl Zeiss at Jena perfected optical glasses from which Ross, Zeiss & Goerz produced 'anastigmatic' lenses fast enough to take advantage of the new plates and shutters.

When his father died in 1894, PK knew exactly where he was going, and was excellently equipped. His major interests were outdoor games and photography, and he determined to combine the two and make a hobby of work. The time was exactly right for a sporting paper illustrated from photographs which the new screen and half-tone process engraving had at last made possible. PK migrated to Berlin and launched his sporting magazine *Sport im Bild* (Sport in Pictures) the following year, when he was only 24. It was a shrewd move. Starting ahead of the rush, PK was nicely poised to cash in on the magazine boom of the Edwardian and Georgian periods, when illustrated weeklies and monthlies became a principal means of communication; the equivalent of television and in-car entertainment today.

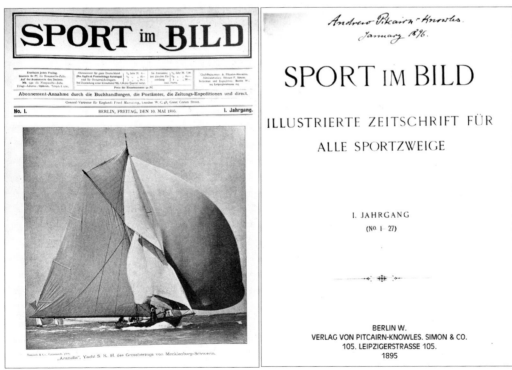

Volume 1, number 1 of Sport im Bild appeared on 10th May 1895

PK's signature of January 1896 in the bound volume of his first 27 issues of *Sport im Bild*

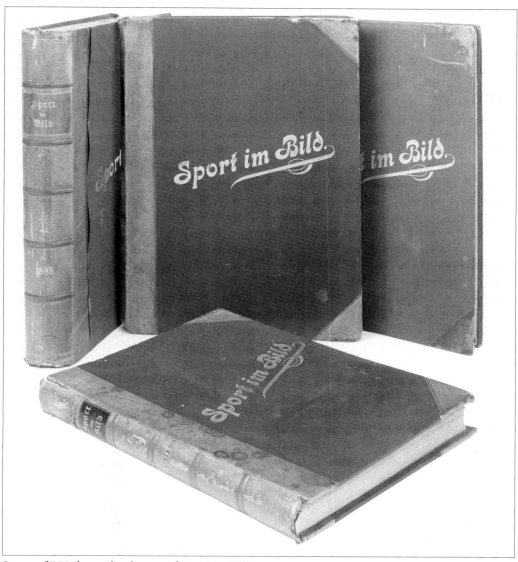

Some of PK's bound volumes of *Sport im Bild*

Volume 1, number 1 of *Sport im Bild* appeared on 10th May 1895. PK's magazine was therefore a couple of years senior to Country Life (founded in 1897) and a month or two ahead of *The Autocar*, Britain's first motoring weekly. It is to PK's credit that he found room in his paper for reports of mechanical as well as athletic sports. *Sport im Bild* gave good coverage of sporting events in Germany and elsewhere, and was also strong on the social side, as was expected in that day and age. PK's own involvement in lawn tennis, football and hockey comes through strongly, while the very title reflects his interest in photography. *Sport im Bild* (Sport in pictures) was followed quite soon, in 1899, by a sister publication, *Sport im Wort*, which offered words without pictures.

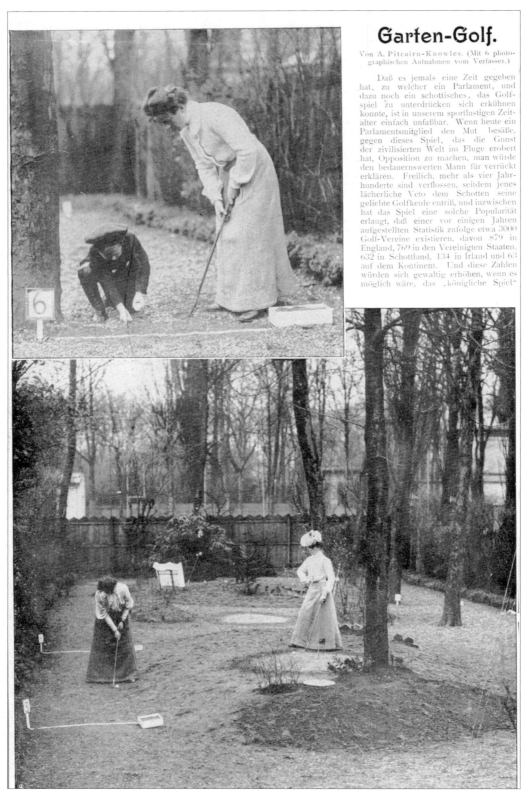

Garten-Golf.

Von A. Pitcairn-Knowles. (Mit 6 photographischen Aufnahmen vom Verfasser.)

Daß es jemals eine Zeit gegeben hat, zu welcher ein Parlament, und dazu noch ein schottisches, das Golfspiel zu unterdrücken sich erkühnen konnte, ist in unserem sportlustigen Zeitalter einfach unfaßbar. Wenn heute ein Parlamentsmitglied den Mut besäße, gegen dieses Spiel, das die Gunst der zivilisierten Welt im Fluge erobert hat, Opposition zu machen, man würde den bedauernswerten Mann für verrückt erklären. Freilich, mehr als vier Jahrhunderte sind verflossen, seitdem jenes lächerliche Veto dem Schotten seine geliebte Golfkeule entriß, und inzwischen hat das Spiel eine solche Popularität erlangt, daß einer vor einigen Jahren aufgestellten Statistik zufolge etwa 3000 Golf-Vereine existieren, davon 879 in England, 769 in den Vereinigten Staaten, 632 in Schottland, 134 in Irland und 63 auf dem Kontinent. Und diese Zahlen würden sich gewaltig erhöhen, wenn es möglich wäre, das „königliche Spiel"

A typical PK article, illustrated with six photographs, published in *Sport im Bild*

8

für die Massen zugänglich zu machen. Aber nicht jeder hat die Mittel und die Zeit, sein Verlangen danach zu befriedigen, denn das Golfspiel gehört leider zu den kostspieligsten und zeitraubendsten Vergnügen auf sportlichem Gebiet. Wer einmal das Golf im Ernst aufgenommen hat, weiß seine Vorzüge und Reize voll zu würdigen, aber die unbequeme „kleine Nebenbeschäftigung", ohne die der Durchschnittsmensch nun einmal nicht gut auskommt, hält Tausende und aber Tausende vom Spiel zurück, die am grünen Tisch, am Küchenherd oder sonstwo zwischen vier Wänden in Gedanken dem Sport huldigen, statt in eigener Person dem kleinen weißen Ball von Loch zu Loch nachzueilen.

„Wenn ich Zeit hätte, wie gern würde ich Golf spielen!" hört man immer wieder und wieder aus dem Munde eines nach körperlicher Tätigkeit schmachtenden Sportlustigen, aber die paar Stunden, die nicht unbedingt dem allwöchentlichen Arbeitspensum geopfert werden müssen, sie reichen natürlich nicht dazu aus, um den Vielbeschäftigten auf den weit außerhalb seines Arbeitsreviers gelegenen „Links" Erholung und Erheiterung suchen zu lassen. Nun, deshalb braucht der Golffreund keineswegs gänzlich auf seinen Lieblingssport zu verzichten, denn er kann sich auf ganz einfache Weise den Genuß — natürlich „en miniature" — zu Hause beschaffen, angenommen, daß er der glückliche Besitzer eines Gartens ist und den Wert einer gesunden körperlichen Bewegung hoch genug einschätzt, um einen Teil des üblichen Gartenschmuckes mit weniger gefälligen „Bunkers" und „Greens" zu vertauschen. Gartengolf blüht und gedeiht schon seit langem jenseits des Kanals, bei uns aber haben die sportfreundlichen Gartenbesitzer bisher nur ein bescheidenes Plätzchen dem Privat - Tennishof einräumen wollen. Vielleicht bedarf es jedoch nur einer kleinen Anregung, um dem Neuling, dem Gartengolf, die Pforten unserer Gärten zu öffnen.

Was die Leser von „Sport im Bild" nebenstehend im Bilde vor Augen sehen, ist eine Schöpfung, die ich in meinem Garten ins Leben rief, als ich mich in einer Gegend aufhielt, wo ich mangels anderer Bewegung mich mit diesem Miniatur-Golf behelfen mußte. Der Garten maß nur 50 Meter in der Länge und 15 Meter in der Breite. Ein Handtuchgestell, ein mit Steinen besäeter kleiner Hügel nebst Graben, eine mit Kartonscheiben behängte Schnur, eine Reihe Bierflaschen und ein aus einem großen Waschbecken hervorgezauberter See bildeten die künstlichen Hindernisse, die sogar dem geschicktesten Spieler immer von neuem verhängnisvoll wurden. Und die natür-

1. Handtuchständer und Badetuch als Ersatz für einen natürlichen „Bunker".
2 Ein Annäherungsschlag über einen „Bunker".
3. Ein Hindernis aus Kartonscheiben. — 4. Eine unbequeme Situation im Gebüsch.

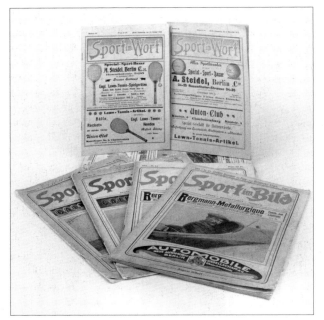

Sport im Bild and *Sport im Wort*

These magazines flourished from the start and PK's name remained as editor-in-chief until the end of 1900. The magazines kept him fully occupied; his mother wrote to him in October 1898 to tell him of the troubles she was having with his sick brothers at home and saying that *Sport im Bild* kept him away from Wiesbaden for too long.

PK also had other calls on his time, for it was in 1898 during this relatively settled period, while the circulation of his magazines was building up, that PK met his future wife, a Scots girl named Margaret Gardner. Margaret was in Berlin, chaperoned by her sister, Elizabeth, to study music and teach English. Andrew met the girls at the Anglo-American tennis club in Berlin, as wholesome a venue as anyone could have wished. After formal introductions and slightly less formal letters (see Margaret's letter of January 1899 about arrangements to go to a gymkhana), Andrew

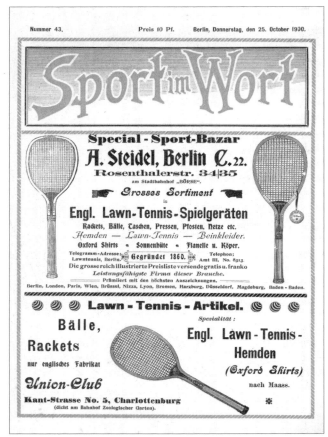

The front cover of *Sport im Wort*, 25th October 1900

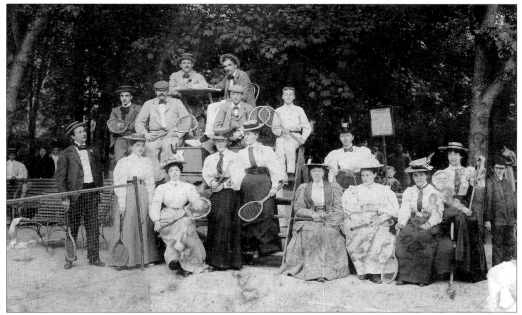

This could be tennis at the Anglo-American Club, PK is top left, but Margaret is not present

Nettelbecksh 6.

Dear Mr Knowles,
We should like very much to see the Gymkhana this evening.
We both have pupils but can manage to chuck them — shall be ready at 6-30 when you come.
Yours sincerely,
Madge Gardner.

Margaret's first letter to PK. A little reckless perhaps? They were married within a year

proposed to Margaret and they travelled home to England to be married within the year at the Strand Registry Office in London on 13th September 1899; he was 27 and she was 22. They set up house in Charlottenburg, a suburb of Berlin, and Margaret gave birth to their only child while living there: Gordon was born on 9th August 1900. With his wife and child and work and sport to occupy him, PK became even more out of touch with his mother in Wiesbaden, and with his brother, James, who had gone off to live with an illegitimate daughter of Napoleon III, arousing Andrew's disapproval. Sister Belle had died several years earlier when aged only seven.

11

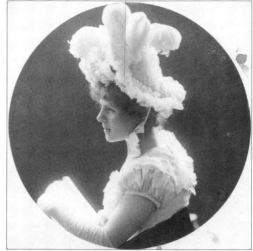

PK aged about 26 Margaret aged about 21

PK was now, by all accounts, fully occupied, and any spare time left after his work in publishing his magazines was devoted to playing and organising sport. A selection of cuttings from papers and magazines of the period shows his remarkably broad involvement in sporting activities.

Ice skating and ice hockey

Winter sports were a major interest. There are more cuttings surviving about PK's involvement in bandy (ice hockey) than any other sport. He pioneered international ice hockey between England and Germany.

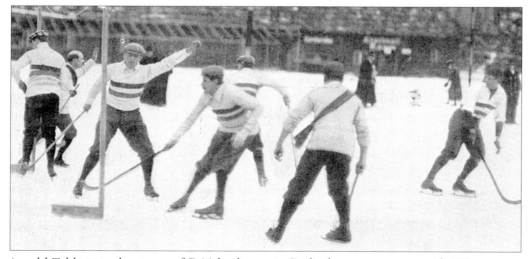

Arnold Tebbutt took a team of British players to Berlin by arrangement with PK

The Illustrated Sporting and Dramatic News of 4th March 1899 describes the tour of a team of English bandy players, starting from Victoria station on 3rd February and including a series of matches in Berlin. Mr Arnold Tebbutt of Winchester made all the arrangements with PK. Another cutting starts,

> *Last winter Mr Pitcairn-Knowles, the editor of the principal sporting pictorial paper in Berlin, wrote to Mr Tebbutt and asked whether it would be possible for him to organise and bring over to Berlin a team to play a series of bandy matches, as they in Germany had taken to the game, and were very keen to meet some of the players from England, in order to discover how they stood as regarded* (sic) *other people and other countries, and perhaps learn a few wrinkles about the game itself.*

The English won all but one match.

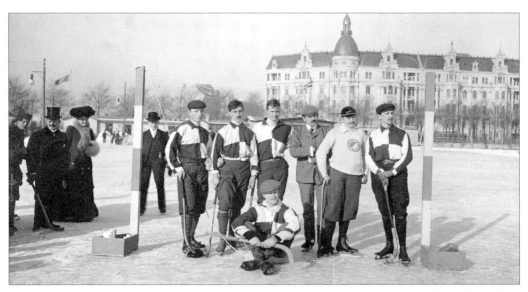

Could this be the Anglo-American Club bandy team in Berlin? PK is third from the right

The Field, The Country Gentleman's Newspaper of 6th January 1900 under the heading Skating, Tobogganing, etc., at Davos and St. Moritz, says,

> '*But the immediate centre of interest is bandy. By the time this is in print matches will have been played between Davos and teams from Berlin... representing Academischer Sport Club from Berlin University and the Anglo-American Club... It will be remembered that the Berlin united team inflicted a defeat on Mr Tebbutt's side which played them in the Friedenau Sport Park, Berlin, in February of this year. On this occasion Berlin will have several new players, but in Mr A. Pitcairn-Knowles the Anglo-American club has a strong player...*

APK himself (pen name Vidi) wrote an article on this tour in *Sport im Wort* No.3 (1900), 19 January 1900, p. 20f, titled 'Die Berliner Eishockey-Spieler in Davos'.

In November 1903, when PK lived at 36 Rue de Longchamp, Neuilly s/Seine, Paris, he played on the team of Mr Denny, director of the Anglo-Saxon School in Paris! In January 1908 *La Revue Sportive Illustrée* stated, *"Deux excellents jouers sont actuellement à Bruxelles, A. Pitcairn-Knowles, le brillant Half-back de Club des Patineurs de Paris,..."*

Hockey
A cutting (by 'Bully Off'), from another but untitled newspaper discusses the *"missionary work"* of an English representative team, containing seven internationals, going to play a Belgian team drawn from the Brussels Hockey and Lawn Tennis Club and other local teams, with the umpire being Mr Andrew Pitcairn-Knowles.

> *Mr A. Pitcairn-Knowles, who is president of the Brussels Hockey and Lawn Tennis Club, is largely responsible for the progress made in Belgian hockey, and he also introduced the game to Germany. He is therefore one of the pioneers both in Germany and Belgium. It is nothing short of remarkable how British residents abroad foster and promote sport in the countries of their adoption.*

Margaret also made her mark both on the hockey field and in the columns of *The Hockey Field* magazine, writing as 'An English Girl in Berlin' and describing the Anglo-American Club and its offshoot, The Berlin Hockey and Radpolo Club, as the best. She further described the nurturing of hockey in Germany, and especially the development of the game for women.

A photograph of the formidable ladies team from the B.H.R.C. shows Margaret second from the left in the front row. An illustrated article in a French magazine is a nice example of reports showing how both Andrew and Margaret encouraged training for the lady hockey players, and the formation of the first ladies' team in France.

A 20 pfennig programme of 2nd December 1900 shows the connection that *Sport im Bild* and *Sport im Wort* had with hockey, especially the B.H.R.C. as shown on the back page of the programme.

In the West clubs are increasing rapidly. *Plymouth, One and All, St. Neot's, Falmouth,* and others are all coming to the front this season.

Ryhall had its general meeting enlivened by a discussion on the subject of "Coaches." Miss Cayley was re-elected captain and secretary, and Mrs. Helby vice-captain.

Anstey Physical Training College held its general meeting on Friday, October 11th, when the following were elected on the committee: B. H. Grieve, A. H. Knight, M. Spalding, H. Hankinson (under-secretary), and G. Bache (captain). The first match is on October 28th, v. Wollescote, on the home ground.

Polam Hall, Darlington, has 150 members, which seems an enormous number. It must be exceedingly difficult to organise such a big club, but they ought to be able to pick a very strong team.

North London Collegiate School is starting its third season with a membership of fifty-eight.

Grassendale has every prospect of a successful season. This is one of the best-known school clubs, and can hold its own against any team in Hampshire.

The High Schools are all starting hockey clubs. Oxford, Dover, Notting Hill, Manchester, Kensington Park, Dulwich, Edgbaston, and the Quadrant School have all begun play.

West Bromwich.—At the annual general meeting held in May the following members were elected on the committee for the season 1901-1902: Misses Langley Browne, Braithwaite, Blake-Atkinson, Guest, Sansome, Silvester, and Bache (captain).

Roedean School.—Miss T. Lawrence has promised us an account of the history of Roedean School hockey, which ought to be of interest to all Old Girls.

The Pickering Stick.—Pickering is a name familiar to all hockey players, and the new stick bearing this name seems likely to become equally famous. We shall probably offer one as a prize in a future competition.

NOTICE TO SUBSCRIBERS.

One Copy	2½d. post free.
Whole Season	5s. ,, ,,
Foreign Subscribers	6s. ,, ,,

Postal Orders payable to Miss Edith Thompson, 16, *Ladbroke Terrace, London, W.*

CONTENTS.

HOCKEY IN BERLIN.

A FEW years ago hockey in Berlin was unknown, and though it is rapidly increasing in popularity, and the hockey craze is likely to correspond to the football fever (which Berlin took very badly a few years ago), it is even now only known to the comparatively few. "Hockey? Do you mean cricket?" is the usual question that is asked if one mentions the game. And if any brave hockey player ventures to walk to the play ground armed with stick and pads, she is sure to excite great interest and some not very complimentary remarks from the passers-by. Although a few years ago, as I said, hockey was not played in the German capital, Berlin now boasts many hockey clubs, the best being the Anglo-American and the Berliner Hockey and Radpolo Club, for if the "Deutschers" go in for anything one may be sure they will do so thoroughly.

The Anglo-American consists, I believe, of only English and American members, but the B.H.R.C. is more cosmopolitan, its members coming from America, England, Germany, of course, and one from Denmark. However, to give to each its due, the Anglo-American was the pioneer of hockey in Berlin, and thereas worthy of all praise. A small set of English and Americans decided in 1899 to meet together on certain days to play the game, and as in Berlin, like all foreign towns, there is a large English and American population, the club flourished and grew, until in the second year of its existence it became too large, and therefore separated into two parts, the new club calling itself the Berliner Hockey and Radpolo Club, of which my friends became members. This new club was as successful as its founder, and the Germans, who at once joined, were a great acquisition. When we first joined this club the Germans were quite new to the game, and it was most amusing to watch them play. Thanks, however, to the captain, secretary, and above all to their own enthusiasm, the Germans in a surprisingly short time became really splendid players, in many cases even better than the English, who had played as many years as they had months. I am now speaking of the German men, for the women, with one or two exceptions, never played really well—but, indeed, how can one expect that they should, considering that until the last two or three years the girls never by any chance took any exercise, and by thirty had all settled down into the traditional "Hausfrau." Even now the Germans are not accustomed to their daughters behaving like rational beings, and the girl who goes in for hockey must be prepared to resign herself to being considered, if not "fast," at least "eccentric!"

Perhaps in a few years this will cease, however, and hockey will be played in all German schools. Let us, indeed, hope so, for the amount of good it would do is inexpressible.

Talking of schools, I must not forget to mention the plucky little "Feudal Club," consisting only of German schoolboys. It was very enterprising of them to start this club, especially so when one considers that games are practically unknown in their hardworking schools, and that this is certainly the first of its kind.

Then, again, another very enterprising club is the Ladies' Treptow Team, whose captain plays extremely well, and if success does not crown her unceasing enthusiasm and energy—well, it ought to!

There are many other clubs in Berlin, but I am afraid I know nothing about them, and besides, I must draw this short account to a close. However, before doing so I cannot resist saying a few words in praise of the club of which I was a member. The B.H.R.C. (and this is not a member's partiality) is by far the best club in Berlin; it has the best ground—on the Athletic Sportplatz; its play is excellent; it has beaten every other club in Berlin, and, what is more, it is constantly going to other German towns to play matches and introduce the game there; and if hockey becomes as widely played and appreciated in Germany as in England, it will certainly be greatly owing to the B.H.R.C. And let me remind my readers that introducing hockey is not merely introducing the game, but the love of health, energy, and outdoor sports—and what is more important than these? Nothing is so healthy as fresh air and exercise—and where does one find fresher air than in a broad hockey field.

An English Girl in Berlin.

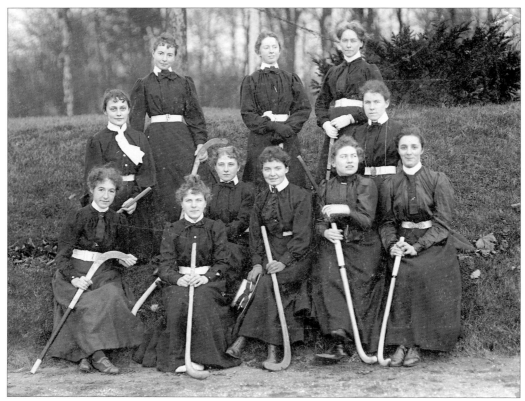

Margaret (front row, second left) with her ladies' hockey team

L'EMERAUDE
UN CLUB DE HOCKEY POUR LES FEMMES

IL N'EXISTAIT PAS EN FRANCE de club de hockey pour les dames. En Hollande, au contraire, et en Angleterre, les femmes aiment ce sport. L'Association anglaise de hockey pour dames compte cent vingt-sept clubs affiliés, auxquels il faut ajouter tous les clubs indépendants. On sait en quoi consiste le jeu. Il se joue entre deux camps de onze joueuses formant deux équipes. La balle est lancée et reprise avec des crosses. Il faut la faire entrer dans le but du camp adverse. Ces règles ressemblent à celles du foot-ball, mais moins rudes, et veulent moins de force que d'agilité et d'adresse. De plus, le jeu se joue en hiver, et succède heureusement aux autres jeux, d'Octobre à Mai, au moment où l'hiver les rend impossibles. Une heureuse initiative vient d'introduire en France ce jeu, en tant que jeu de dames. L'idée en est venue à Mlle Masson, la tenante du championnat de tennis de France, et fut accueillie avec enthousiasme par d'autres « sportswomen », telles que Mlles de Saint-Amant, Mlles de Pfeffel, Mlle Franckel, Mlle Lysaght. En quelques semaines deux équipes étaient complètes. Parmi les membres, citons : Mlle Poitiers, Mlle Gavarni, Mlle Ash, Mlle de Saint-Amant, Mlle d'Arbal, Mlle Journault, Mme Knowles, Mlle Forbes, Mlle Cory, Mlle de Revelbach, Mlle Franklin, etc., etc. Beaucoup de demandes d'inscription pour l'automne ont été faites. La première réunion a eu lieu le lundi 14 Mars par une journée printanière sur le terrain de hockey de Billancourt, dans l'île de Saint-Germain : endroit charmant enfermé dans les saules et les peupliers, et baigné par le fleuve, dans le cadre des collines bleues de Meudon. Ce terrain, où se disputent les meilleurs matches des équipes d'hommes, appartient à l' « Anglo-Saxon School », et a été gracieusement prêté à l'Emeraude par M. Denny qui, le jour de l'inauguration, s'était aimablement mis au service de l'équipe comme capitaine, ainsi que M. Knowles.

This illustrated article from a French magazine demonstrates how PK and Margaret encouraged training for the lady hockey players, and the formation of the first ladies' team in France

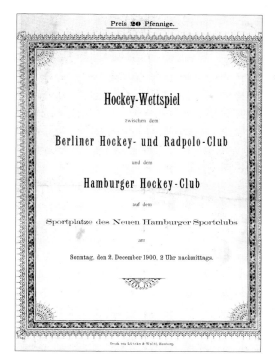

Das Hockey-Spiel

stammt aus England, dem Mutterlande des Sports, und ist erst seit einigen Jahren in Deutschland eingeführt worden. In Berlin existiren z. Zt. 6 Hockey spielende Clubs, und Hamburg hat seit September 1898 einen aus Damen und Herren bestehenden Hockey-Club. Das gegenwärtige Wettspiel ist das erste des Hamburger Hockey-Clubs, wie überhaupt das erste Hockey-Wettspiel in Hamburg. In Ermangelung von für das Wettspiel geeigneten Plätzen hat der Neue Hamburger Sportclub sein Terrain in liebenswürdiger Weise zur Verfügung gestellt.

Gewöhnlich nehmen 22 Personen am Spiel theil, und zwar je 11 auf einer Seite, welche in Stürmer, half-baks, backs und goalkeeper eingetheilt werden. Das Spiel gipfelt in dem Bestreben jeder Partei, den Ball mittelst des Hockey-Schlägers durch das gegenüberliegende goal zu bringen. Eine Hockeypartie dauert 1 Stunde und 10 Minuten; nach 35 Minuten (half-time) tritt eine Pause ein, worauf Seitenwechsel vorgenommen, und abermals 35 Minuten gespielt wird. Ein Eingehen auf Einzelheiten des Spieles, welches nach verhältnissmässig komplizirten Regeln betrieben wird, dürfte zu weit führen. Jeder, der sich für Hockey interessirt, findet genaueren Aufschluss in dem im Verlage von „Sport im Bild" Kurfürstendamm 239, Berlin, erschienenen Heft: „Die Regeln des Hockey-Spiels". Dasselbe ist gegen Einsendung von 20 Pfg. vom Verlage zu beziehen; auch geben die Vorstandsmitglieder des Hamburger Hockey-Clubs, Herr E. A. Stone, Marschnerstrasse 7, und Herr Hans Kröger, Hamburgerstrasse 185, bereitwilligst Exemplare zum Selbstkostenpreis an Interessenten ab.

Ausführliche Berichte über dieses Wettspiel bringen
„Sport im Bild"
und das officielle Organ des Hamburger Hockey-Clubs
„Sport im Wort".

A 20-pfennig programme of 2nd December 1900 shows the connection that *Sport im Bild* and *Sport im Wort* had with hockey, especially B.H.R.C.

Cycling

Steeple-chasing on bicycles is featured as one of the races in the programme of the Berlin Hockey and Bicycle Polo Club for 21st October one year, when a Cycling Gymkhana presented a ladies' hockey match, cycle polo and assorted cycle races. A. Pitcairn-Knowles, as chairman of the committee, and Mrs Pitcairn-Knowles and her sister, Miss Gardner, featured prominently among the prize winners, as did a close friend, Ida Praetorius, who was later to become an artist living in St Ives.

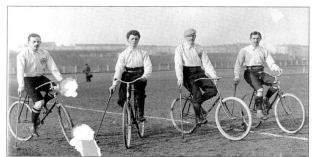

Bicycle Polo

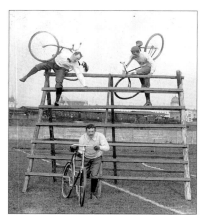

Steeplechasing by bicycle!

Another programme of the Berlin Hockey and Bicycle Polo Club shows that Mrs Pitcairn-Knowles and her sister, Miss Gardner, featured frequently among the prize winners

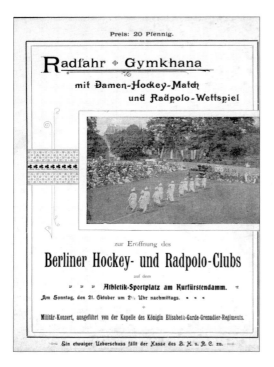

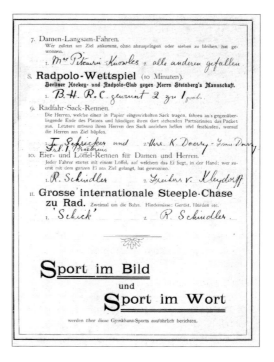

Tennis

"The Brussels Hockey and Lawn Tennis Club's Championship Tournament was brought to a conclusion last Saturday; Mrs Pitcairn-Knowles was Lady champion and runner up in the ladies doubles." Tennis featured strongly in both Andrew's and Margaret's lives but there is less record of this sport than others.

Football

A photograph of PK as captain of a football team, the Anglo-American Club shows him sitting in the centre of the front row holding the ball. There is a family rumour that PK was the first person to kick a football in Austria.

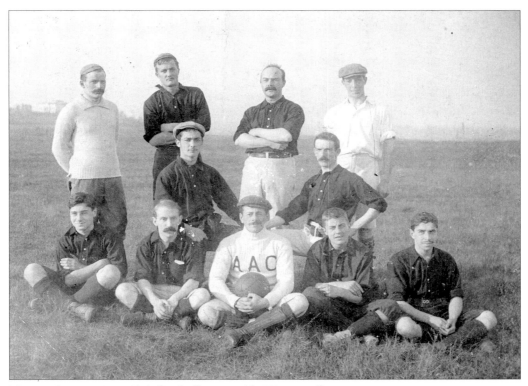

The Anglo-American Club football team with PK as goalkeeper

Cricket

In an unknown (probably Edinburgh) newspaper it was reported that the Royal High School Cricket club from Edinburgh, thanks to the energy of Mr J.J.

Trotter, ventured to Copenhagen and Berlin for a successful tour. In Berlin they

> *were guests of the Preussen Club, the members of which vied with the Danes in their hospitality. Nor can we forget the kindness shown to us by Mr Knowles, editor of the chief German sporting paper, and his friends. The afternoon tea, presided over by Mrs Knowles, at the ground of the Preussen Club, was to many the most enjoyable incident of the tour. It was like finding a bit of the old country in the heart of Germany.*

So, was PK settling down into a rut?! Most of us would have thought he was leading a rather full life. But he had other ideas. Having seen his magazines safely launched he looked for a change. The announcement in *Lawn Tennis* Magazine of 8th May 1901 that he was about to move to the columns of *Sankt Georg*, the official organ of the aristocratic sporting world in Germany, was apparently never confirmed and he went into orbit as a freelance journalist and photographer, often taking his family with him, and continuing his sporting interests between articles.

Photography had made great strides between 1890 and 1900, changing in those years from a static to a dynamic art. The camera moved off its tripod and into the user's hands. Optical definition improved enormously with the anastigmatic lenses of Ross, Goerz and Zeiss which became popular during the 1890s and culminated in the first Zeiss Tessar of 1902. During the 1890s, too, the C.P. Goerz company of Berlin introduced the rapid and practical focal-plane shutter which they had developed in collaboration with Ottomar Anschutz. This shutter became the basis of the Goerz-Anschutz Press camera, and also figured in the design of the big single-lens reflex instruments that PK was to make so much his own, and of which he was one of the finest exponents.

Our guesses that PK used a large reflex camera were not confirmed until we spent many happy hours at the British Library hunting through the bound volumes, held at the British Museum in Great Russell Street and at Colindale, for articles by PK in magazines issued between 1895 and 1925. Altogether 25 articles were found, all except one illustrated by PK's own photographs. Articles appeared mostly in *Wide World* magazine but also in *The Badminton Magazine, Outing, The Illustrated Sporting and Dramatic News, Sport im Bild* (of course) and the French magazine *Lectures Pour Tous*. It is certain that more extensive

How Cabbages are transformed into Walking-Sticks.

By A. Pitcairn-Knowles. Photographs by the author.

"Sunny Jersey", as the most popular of the Channel Islands is deservedly nominated by its inhabitants and its numerous admirers who flock to its shores in quest of health and pleasure, can proudly boast of being one of natures most favored creations. Embraced, as it were, by the warm waters of the Gulf Stream, and well protected from the biting gusts from north and east by numerous hill ranges, it enjoys a winter-climate more favorable even than that of many noted winter-resorts in the South of France, and although not possessed of the azure skies and the wealth of sun that make some of the latter places the points of attraction for those who flee the discomforts of an English winter, Jersey is blessed with a higher yearly record of sunshine than any part of England. Little wonder then that the soil of this happy little island works miracles and produces fruits and vegetables which are the envy of many a struggling farmer who has no Gulf

The only surviving page in PK's own handwriting of one of his articles reproduced on the following pages

21

WHERE WALKING-STICKS GROW

by A. Pitcairn-Knowles

F.R.Horsman

A chatty description of the quaint "vegetable walking-stick" industry of Jersey. This sunny isle rejoices in the possession of a remarkable cabbage, which apparently cherishes the ambition of becoming a kind of universal provider. Reaching sometimes to the height of seventeen or eighteen feet, it furnishes excellent walking-sticks, nutritious food for man and beast, and a substitute for butter-paper! The author gives some interesting facts about this useful plant and the brisk little trade that has grown up around it.

"SUNNY JERSEY," as the most popular of the Channel Islands is deservedly called by its inhabitants and the numerous visitors who flock to its shores in quest of health and pleasure, can proudly boast of being one of Nature's most favoured domains. Embraced, as it were, by the warm waters of the Gulf Stream, and well protected from the biting gusts from north and east by numerous hill-ranges, it enjoys a winter climate more favourable even than that of many noted winter-resorts in the South of France. Although not possessed of the azure skies and the wealth of sun that make some of the latter places the points of attraction for those who flee the discomforts of an English winter, Jersey claims a higher yearly record of sunshine than any part of England. Little wonder is it, then, that the soil of this happy island works seeming miracles and produces fruits and vegetables which are the envy of many a struggling farmer who has no beneficent Gulf Stream to aid him in his endeavours to cope successfully with his foreign rivals. This little paradise likewise brings forth a plant as curious as any that has been given to mankind to utilize in any manner it may think fit.

This plant is one of the members of the wide-branched family of the cabbage; but the Jersey cabbage differs from all its brothers and sisters inasmuch as it is not merely an ordinary vegetable, destined to satisfy the appetite of hungry man, but has greater ambitions and abilities, which place it far above the level of its unaspiring relatives. To be eaten and appreciated as a food by mankind is only one of its *raisons d'être;* but the more important one is to supply our queer menfolk, who delight in burdening themselves with cumbersome walking-sticks, with fine specimens of this indispensable article.

When you emerge from St. Heliers, Jersey's capital, and wend your way through the numerous ever-verdant valleys, past the snug cottages and the flourishing farms, amid the luxuriance of vegetation you will behold in almost every farm or garden this useful cabbage plant, or "chou-cavalier," as the French-speaking natives of Jersey call it, standing proudly erect, with its tufted top towering above everything that grows in the fields except the trees. Here you may see a dozen of them sheltering the door of a little hut, there a big cluster grown to supply the cattle with food, and sometimes even

The completed article reproduced in full from *World Wide*, September 1906, illustrated with PK's own photographs. There has been a change of title

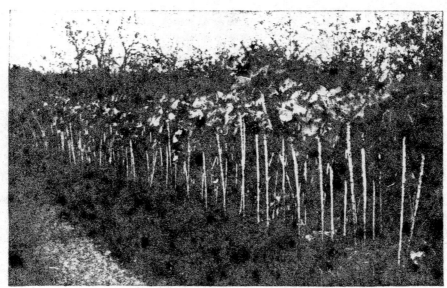

From a Photo. by] A PLANTATION OF "WALKING-STICK" CABBAGES. [*the Author*

a large stretch of land may have been given up to the cultivation of the "choux." Occasionally, too, you may notice them placed in a line along the edge of a garden, forming a picturesque and tidy border and a quaint kind of fence.

If it happens to be March or thereabouts you may see people engaged in selecting the finest specimens and cutting the tallest stalks deemed worthy of being transformed into beautiful walking-sticks, for this is the time of the year when the stump, after having been left in the ground over winter, has attained sufficient hardness to permit the manufacturer to continue the work Nature has commenced. But the transformation of the rough cabbage-stalks into walking-sticks entails a great amount of labour.

The stumps brought in from the farms are first placed in the shade till thoroughly dry, the quicker process of drying in the sun being impracticable on account of the sticks cracking. Large tanks of water await the dry sticks, and there they are left to soak till they become

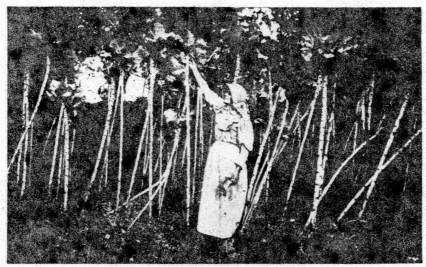

SELECTING THE TALLEST STALKS FOR CUTTING—PLANTS HAVE BEEN KNOWN TO REACH THE PHENOMENAL HEIGHT OF EIGHTEEN FEET!
From a Photo. by the Author.

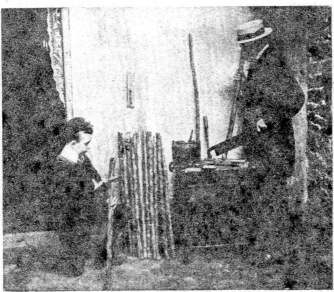

TRANSFORMING THE CABBAGE-STALKS INTO WALKING-STICKS.
From a Photo. by the Author.

'manufacturing cabbage-sticks can be witnessed in its different stages. Mr. George Bishop, the largest manufacturer of Jersey's local curiosity, has even turned the whole of his shop-window into a regular museum of cabbage-sticks, containing some of the most perfect specimens that the Jersey cabbage-growers and his own hands and tools could produce. First and foremost among his "master-pieces" ranks "Jumbo," the giant of cabbage-sticks, which can boast of such a height that even the tallest man in the world would find no use for him. Nevertheless many an admirer of "Jumbo" has wanted to

supple. This accomplished, the crooked parts are straightened, after which the pith is removed by means of long augers and when necessary replaced by plugs of wood for the purpose of keeping the bent parts straight. The ends are then pointed to receive the ferrule, and the surface having been smoothed down with glass-paper, three coatings of varnish bring the manufacturer's task to an end. The sticks having

become the possessor of this curiosity, but the owner has so far not felt inclined to part with the treasure that undoubtedly forms one of the sights of "Sunny Jersey," and above all of his own shop-window.

It was "Jumbo's" head-quarters to which some years ago Lord Rosebery, when visiting the island, made his way, in order to procure a few of Jersey's quaintest mementoes, and several

undergone this treatment are as strong and serviceable as they are light, and—what is of most importance to sellers and buyers alike — their appearance is attractive, especially when adorned with the pretty silver top bearing the Jersey coat-of-arms. Thus it is not surprising that some of the tobacconists, finding it almost as paying to sell cabbage-sticks as to supply the wants of the smoker, have turned part of their business premises into workshops, where the above described process of

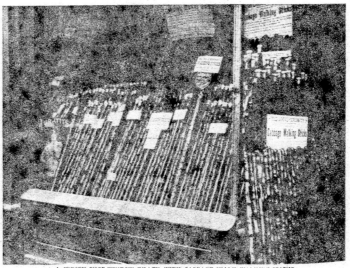

A JERSEY SHOP-WINDOW FILLED WITH CABBAGE-STALK WALKING-STICKS.
From a Photo. by the Author.

"JUMBO," THE GIANT OF ITS TRIBE—ITS PROUD OWNER HAS REFUSED MANY TEMPTING OFFERS FOR THIS SPLENDID SPECIMEN.
From a Photo. by the Author.

Thus, while Jersey potatoes undoubtedly pay better, we see that this island is a good many thousands of pounds the richer for being able to produce a plant that grows walking-sticks, and which in this island reaches dimensions attained nowhere else. It is said that some particularly energetic and ambitious cabbages have established the wonderful record of eighteen feet !

This in itself is a feat that most other vegetables would sacrifice any of their qualities and powers for, but the Jersey cabbage apparently desires to make itself useful all round, to man and beast alike, for every bit of it, except perhaps the root, can be utilized—its stem as a walking-stick, its sprouts as a vegetable, and its leaves for feeding cattle and packing butter. Furthermore, as I have already mentioned, in its endeavours to be useful and ornamental at the same time it provides its grateful owner with quite a welcome variety in the way of a substitute for the ordinary garden hedge. The Jersey cabbage certainly has a future before it, if only a means could be discovered which would enable all the world to bring it to the height of perfection and stature it reaches in "Sunny Jersey."

of "Jumbo's" small brothers have been selected for presentation to the Prince of Wales. "Jumbo" himself, however, remains true to his allegiance and an ornament to his native isle, though some day, perhaps, he may have to make way for a still greater rival.

As to the origin of the idea of turning cabbages into walking-sticks little is known, so far as I could ascertain, except that it was more than forty years ago that this peculiar industry was started. Since then many thousands of sticks have left the island, travelling to almost every part of the world, and according to an estimate some thirty thousand sticks are sold annually at prices ranging between two shillings and ten shillings.

From a Photo. by] "THE LONG AND THE SHORT OF IT." *[the Author.*

research through French, German, Belgian and even perhaps other British magazines of that era would unearth more of PK's writings e.g. (in German) on 'Lawn Tennis in England', in Lawn Tennis und Golf (1913), p 622f. This was made very apparent more recently when a friend let us have sight of four copies of the German magazine *Die Woche* from 1905–1907 which had been found by her German mother who had been turning out her attic in east Berlin. Here were two more articles with photographs of which we had been unaware. The magazines had probably been stored there for over 80 years! All this detective work produced a great deal of information and, having become so immersed in the period, the thought of clues sparked our imagination. We moved easily across to the *Wide World's* rival, *The Strand*, to consult Sherlock Holmes on the matter:

Let Watson report what transpired:

Mrs Hudson had barely cleared away the breakfast things when an envelope containing photographs was delivered by District Messenger. Upon these Holmes eagerly seized, having only the previous evening brought a case to a successful conclusion.

"The sender appears to have omitted to enclose his card, Watson," said Holmes reaching for his first pipe of the day.

"Then we must wait until he deigns to put in an appearance," I remarked, "for the photographer (assuming it to be he) has failed also to include a self portrait."

"On the contrary, Watson, he has served us well."

"You know him then?"

"Only from what these pictures reveal. We have here a tall, vigorous, athletic man with easy manners, an open mind and some interest in the arts. He leads an active outdoor life, has considerable means and is a fluent linguist. He most probably resides abroad. So much is evident, you will agree?"

"Extraordinary, Holmes!"

"On the contrary, a box of prints can be most eloquent. The subjects range from the North Sea to the Mediterranean, as witness the countryside, costumes and occasional fragments of lettering. Continental subjects largely outnumber

the English, so he probably resides abroad. There is nothing strange or awkward about his peasants; he therefore has a knack of putting people at their ease, which argues the gift of tongues. The compositions are harmonious; our man is an artist not merely a master of his craft." Holmes picked up The Times *with an air of finality.*

"So much I grant you," I pursued. "But how can you be sure of his build, or of his means, for that matter?"

Holmes ruefully set down the newspaper. "Surely, Watson, you can deduce as much from the photographs themselves, which are mainly contact prints, made by laying a glass negative directly upon the paper; the irregular edges show this, and you will note that the plates vary in size. I would hazard a guess that those on my left measure six-and-a-half inches by four-and-three-quarter inches, the so-called half-plate size, while the others are slightly larger, probably seven by five. Only an athletic man would carry so large an instrument instead of the lighter and more popular 'quarter-plate', and it takes a tall man to get the best from so large a 'single-lens reflex' which must be held at waist level. Such instruments are expensive, so he must be relatively wealthy who owns two of them."

"But, Holmes," I cried, "surely any camera would serve; what makes you say that these photographs were taken with a single-lens reflex?"

"Clearly you are no photographer, Watson," my friend replied, "or one glance would convince you that nothing save a reflex could have done this work. Note the sharpness with which the lens is focused on the principal feature in each case, leaving irrelevant features vague. Only in a reflex camera can the operator observe his subject right up to the moment of exposure and determine by observation rather than guess work which features will be 'pin sharp' and which blurred. A glance at the motor gymkhana (prints 49 and 50) *pictures or the man about to eat a cockle* (prints 70 and 71) *will make this plain. Such nice control of what photographers call 'depth of field' would be difficult with the eye level viewfinder on a Press camera and impossible with Mr Sanderson's 'hand and stand' instrument unless the latter were used on a tripod, in which circumstances all spontaneity would be lost. No, Watson, when our friend's hansom drives up we should have no trouble in identifying its fare."*

27

Since that imaginary conversation we have traced, as we have said before, many of PK's writings. These confirm and amplify Sherlock Holmes's conclusions. PK did indeed use single-lens reflex cameras. In *Wide World* for December 1906 we find PK and Dodo (Margaret) touring the Friesian canals on skates (Print 97). They enquire *"as to the most convenient method of conveying our bulky half-plate cameras over the ice,"* whereupon *"several dozen amiable villagers, attracted by the Engelsman's knickerbockers and strange tongue, and evidently much concerned about our welfare, unanimously agreed that the lightest sledge we could get the loan of would suit our purposes best."* So they possessed at least two half-plate cameras.

Later that day disaster loomed and PK showed his strength:

> *A glorious moon shone upon the sparkling ice and tempted us away from the comfortable arm chairs at the cosy little inn… The recollections of this beautiful moonlight night in Friesland's wintry fairyland was one of the happiest we brought home, but for one little contretemps, which fortunately ended without causing hurt. Whilst spinning along merrily, keeping as much as possible to the middle of the broad canal, where the most tempting black ice enabled us to pass more quickly than alongside the banks, where the surface was far from good, a sudden report, like that of a pistol, startled us, and before we could realise what it meant the sledge, at the time committed to my charge, was slipping away from my hands through a hole in the ice. The warnings of our friends in Heerenveen flashed across my mind, and, pulling back with all my strength, I swung the sledge up into the air and round on to the unbroken ice, thus managing in the nick of time to escape what might have terminated in something more serious than a ducking.*

Perhaps we should add a word about these cameras. The first single-lens reflex Press cameras came on the market during the middle 1890s, just when *Sport im Bild* was launched. There was one that PK probably knew, resplendent in mahogany and brass case by Dr A. Hesekiel of Berlin, which appeared in 1895 and featured a focal plane shutter. The operator peered down through a folding hood at a ground-glass screen on which the precise image captured by the lens was reflected by a 45° mirror. When the shutter release was pressed the mirror swung out of the way, and the exposure was made. The same lens served for viewing and taking. Single-lens reflexes of this sort were made by many manufacturers including Marion in England, whose

'Soho' has given its name to the type as a whole. Confirming Sherlock Holmes's estimate, we have weighed a half-plate example of the PK vintage by the Ica Company, Dresden, and find that it weighs about 12 pounds. Complete with a dozen dark slides, an extra lens and the necessary leather carrying case, the total would not be far short of 30 pounds.

The Ica reflex, kindly weighed for us by Mr Edward Holmes, author of *The Age of Cameras,* possesses a rather useful feature which PK may well have adopted. This is a swivel on the carrying strap which can be hooked on to a cross belt of the Sam Browne type so that the belt takes the weight and the operator has both hands free for focusing and changing slides. Some such arrangement would have been helpful to Margaret for she, although strong and athletic, was quite lightweight in build. The conclusions reached by the mythical Sherlock Holmes were further confirmed by the real life Holmes (Edward) who had helped us earlier, when he examined some of the photographs taken during the skating trip mentioned earlier. He says that in one picture the *"camera is an Adams Minex half-plate reflex",* and in another picture of *"the back of what appears to be a half-plate reflex… it appears to have a Goerz-Anschutz shutter and might, therefore, be one of several types of camera, possibly a Shew or a Sanders and Crowhurst."*

Husband and wife were intensely keen on sport. To remedy a lack of facilities on the Continent, PK seems to have helped to found clubs wherever he settled, including Berlin and Brussels. Family tradition credits him variously with introducing the game of hockey into Germany and kicking the first football in Austria. Margaret seems to have been equally keen. Once the magazines were running under their own steam the family moved on. From Charlottenburg they settled briefly in Jersey where Margaret's sister, Minnie, lived, and tried tomato growing. This they found sedentary, dull and demanding so they moved on. Paris became their base in 1903, at 36 Rue de Longchamp, Neuilly. Their next abode was in Brussels from 1909 to 1911 at 46 Avenue Maurice, after which they moved to the south coast of England and remained there for the rest of their lives.

This final move was brought about by a dramatic chain of events. In 1907 the family visited Corsica. The visit to this island produced an article on Corsican bandits and many excellent photographs of peasants and a hunting party armed with muzzle-loaders (prints 2, 3, 4 and 5). It also completely changed the life of PK and his family and all their descendants.

They say that out of evil cometh good. While the PK family were in Corsica Gordon, aged seven, was kicked in the abdomen by a mule. Complications set in and the boy was given up by the doctors. It was then that PK recalled stories of successes achieved by the natural therapies used in Germany. The family rushed back across Europe by boat and train, caring as best they could for Gordon. They headed for his grandmother's flat in Wiesbaden and stayed there with her so that Gordon could be seen by Col. Dr Spohr, a natural therapy doctor and author of authoritative works on Naturopathy at that time. Gordon began to improve and was then sent to Dr Lahmann's Natural Therapy Clinic in Dresden, followed by a special dry diet cure known as the Schroth Cure, after Johann Schroth, at Lindewiese in Silesia, Austria under Dr Mader. Young Gordon recovered completely and PK was so relieved and impressed that he determined to qualify in the same discipline and to introduce Naturopathy to England. More years of study followed; PK must have been the original 'mature student' at the University of Heidelberg.

A hunt along the south coast of England ended when a suitable house in about five acres was found at Hastings, and this is where PK resolved to found his Nature Cure Hydro . The family packed up and left Brussels and the wandering years came to an end. PK realised his ambition when, with the tremendous support of his wife, he opened Riposo Nature Cure Hydro to resident patients. They specialised in the dry diet Schroth Cure and patients would stay between ten days and six weeks to complete the cure. PK devoted the rest of his life to Riposo, dying there aged almost 85 in 1956.

The photography equipment was put away in the attic room PK had converted to a dark room and used only rarely, and the weighty glass negatives were left to endure extremes of temperatures and dampness stacked on top of one another, and so protecting themselves. Gordon followed in his father's footsteps in his twenties, going to Freiburg University and taking over the reins of Riposo gradually. Over 50 years later, after Andrew had died and after Gordon had also died in 1963, I felt that not all the 'rubbish' in the attic should be thrown out and that there must be some interest in these piles of glass negatives. What a rich haul they made!

Photographically the standard is very high, as was recognised at once by John Maltby, FRPS FIIP, an assessor of many years standing on the nominations board for candidates at the institute of Incorporated Photographers. When shown

❧ HASTINGS. ❧

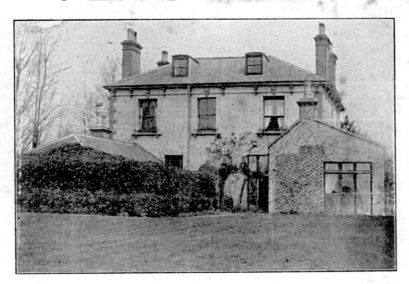

TO BE LET OR SOLD FREEHOLD

A Detached Family Residence occupying a lovely situation, 500 feet above sea level, commanding extensive views, practically in the country, yet in touch with the centre of Hastings and St. Leonards by short Tram journey.

The House, which is double-fronted, contains ;—

On the Entrance Floor :—Four excellent Reception Rooms, one being fitted as Billiard Room, measuring 17-ft. by 15-ft. 6-in., 20-ft. by 15-ft., 19-ft. by 17-ft. and 15-ft. 6-in. by 15-ft. 6-in. Hall : Imposing Conservatory, approached through French casement ; on this floor, well shut off, are the well-arranged Domestic Offices, comprising :—Kitchen, Scullery, Larder, Coal Sheds, &c.

First Floor :—Five Bedrooms, 16-ft. by 15-ft. (with Dressing Room communicating), 16-ft. by 13-ft., 15-ft. by 12-ft., 14-ft. by 12-ft., and 16-ft. by 9-ft. Bathroom, with hot and cold supplies.

Above there are 4 Attic Bedrooms, two with fireplaces.

The house is well fitted with cupboards throughout. Gas and Town Water are installed, and the drains have recently been overhauled under the supervision of the Town Authorities.

The Grounds, of about **Two Acres**, which surround the house, comprise :—Lawns, Fruit and Kitchen Gardens, Orchard and Flower Garden.

Good stabling for two horses, with man's room over.

Freehold, £1,600. Rent, £85.

Small cottage, suitable for coachman or gardener, adjoining, could be had by arrangement.

For Appointment to View apply to
Messrs. BEAGLEYS,
Auctioneers, House & Estate Agents,
59, London Road,

(Telephone 350). St. Leonards-on-Sea.

Ridgecroft, the house at Hastings that in 1912 became 'Riposo, The Knowles Health Hydro'

Pitcairn

Knowles 147

dweg Baondael
Brussel

WATERMAEL
9
OCTO
1911

à (te) H. (uur)

Indications de service les plus usitées inscrites éventuellement en tête de l'adresse, en toutes lettres ou en abrégé :
Meest voorkomende dienstaanwijzingen die, als er zijn, voluit of verkort vóór het adres worden geschreven :

D { Télég. urgent / Dringend teleg. RP { Réponse payée / Antwoord betaald XP { Exprès payé / Bode betaald PC { Téleg. avec accusé de réception télégraphique / Teleg. met telegrafische kennis-geving van ontvang PCP { Téleg. avec accusé de réception postal / Teleg. met kennisgeving van ontvang per post

L'Etat n'est soumis à aucune responsabilité à raison du service de la correspondance privée par voie télégraphique (Loi du 1er mars 1851, art. 6).
Luidens art. 6 der wet van 1n Maart 1851, is de Staat geenszins verantwoordelijk voor den dienst der bijzondere telegrammen.

Déposé à
Aangeboden te Hastings à 426 N° 2105
te

Meadows offered 1050

for ridgecroft will

accept unless your complete

Contract Elliott

A telegram shows that PK almost lost Ridgecroft, later to become Riposo, at one stage

the negatives by D.B. Tubbs, he showed great enthusiasm and at once agreed to make prints. The enlargements that followed were shown to Sue Davies, then director of the Photographers' Gallery in London. Her immediate reaction was "*We must hold a show at once!*" Here, it was realised, was an archive of great value and a new name to be placed alongside those of Eugene Atget and J.H. Lartigue as one of the greatest chroniclers of the Edwardian Age. An exhibition was held in April 1973 at the Photographers' Gallery, Great Newport Street, London, billed as "Pre 1914 Reportage from Europe." *The British Journal of Photography* in its review at once realised its importance. "*These early pictures now on view at the Photographers' Gallery are of unique interest and show that Andrew Pitcairn-Knowles was an early and brilliant photo-journalist.*" After its London run the exhibition went on tour in Britain and on the Continent. Two years

32

later when the Arts Council staged a big retrospective exhibition at the Hayward Gallery, London, called *The Real Thing–An Anthology of British Photographs 1840–1950* the newly discovered Andrew Pitcairn-Knowles found himself among the immortals: Hill and Adamson, Fox Talbot, Julia Margaret Cameron, Sutcliffe, Brandt, Sir Cecil Beaton… None, however eminent, was allowed more than 12 prints, and PK was represented by 12. *"The great contemporaries of Pitcairn-Knowles,"* wrote Ian Jeffrey in his catalogue introduction, *"were Herbert Ponting, the photographer of Scott's Antarctic Expedition of 1910–1912, and Horace Nicholls who photographed the Boer War."* Praise indeed.

It would be wrong, however, to call PK a Press photographer, despite his involvement with magazines. Perhaps the nearest he came to topical journalism was his coverage of S.F. Cody when that pioneer aviator was experimenting with weight-lifting kites (prints 26 & 27). Intrigued, as always, by off-beat activities, PK took a number of pictures; partly one feels for documentary interest of the subject but also for the pictorial affinities of Cody's broad-brimmed hat and brooding attitude, with the bat-like outline of the box-kite, intended here for towing a boat. The recognition of such affinities, a sort of visual punning, was to become almost a cliché with the photo-reporters on *Lilliput* and *Picture Post* during the 1930's; its use so early by PK is very striking. For another example one need look no further than print number 53 in which a japanned birdcage echoes the man's eye-patch while the bollard echoes the wooden leg. The peg-leg and the eye-patch in this print are piratical, even macabre. The same element crops up elsewhere in PK's work; but it is objective, never sinister or prurient.

For a humanitarian, a vegetarian even, since his contact with the Lahmann Clinic, he seems oddly unsqueamish about the bloodier pastimes of bucolic Germany; existentialist may be the word. Badger-baiting and cock-fighting were there to be reported, not judged (prints 22, 23, 24, 25, 67, 68 and 69). It may be that these pastimes were less cruel than one imagines, for the Ratodrome ring-master looks a kindly old party, caring for the wounds of badgers and hounds alike, and the badgers seem not downcast. There is an affectionate gleam, too, in the eye of the fighting cock's owner. In his portrayal of working people and unusual trades, PK reminds one of Mayhew's *London Life and the London Poor*,

except that PK's characters hail not only from the Home Counties but from many parts of Europe as well. The violet pickers (print 66), the sea-urchin fisherman (prints 58, 59 and 60) the pig woman, and the Paris street market scenes (prints 53, 54, 55, 56 and 57) place PK among the social realists; he was, after all, working at the same time as the painter John Sloan and the Eight in New York, the so called 'Ash-can School'.

The shop fronts (print 39) and genre studies by PK are remarkable for their life as well as their wit. In this they differ from the work of that other witty practitioner, Eugene Atget (1857–1927), a professional photographer whose sharp eye for the incongruous has led some historians to call him a precursor of surrealism. Unlike PK, Atget worked in the studio manner as people had done for 50 years. He set up his camera, composed with his head under a black cloth and took time exposures, methods that produced pinsharp negatives full of detail, but which precluded movement. Atget is known to have worked with a trousse (kit) of casket lenses probably by the Paris optician Darlot, which could be used in combination to give a choice of focal lengths. Atget's exteriors were taken 'on location' but by techniques that would have applied equally in the studio. He was passive while PK was dynamic.

For elegance combined with movement one thinks of that other French master, JH Lartigue who was active in Paris at the same time as PK, who in 1905 moved to 36 Rue de Longchamp, Neuilly-sur-Seine. Jaques-Henri Lartigue, the brilliant boy photographer, mastered the Kodak roll-film Brownie when he was seven, (he was born in 1894) but by this time was using a vest pocket (4.5 x 6cm) Gaumont 'Block-Notes,' then the latest thing in miniature plate cameras costing, Lartigue tells us, 100 (gold) francs *"which would have bought ten excellent dinners in a good restaurant"*. Small and slim like a memorandum pad (hence the name) a Block-Notes was pocketable when folded and had the merit of using glass plates which lay flatter than roll film, offered a wider choice of emulsions, and made better enlargements; it could also be wielded discreetly, which was an advantage when photographing ladies in the Bois whose escorts sometimes objected to the 'black box' wielded by Lartigue in his teens.

During la Belle Epoque when Lartigue was active, if only on the sidelines, capturing le tout-Paris and the demi-monde on the ironically named Sentier de la Vertu, PK was exploring the back streets and markets. His was a more democratic lens, but he was no mere low-life Lartigue; PK could render elegance when he chose. His race-goers anticipate Cecil Beaton's Ascot sets in *My Fair*

Lady (print 63), and the lady playing diabolo is both graceful and smart (prints

35, 36 and 37). Here the reflex camera shows to advantage: every stitch in the dresses is sharp. PK was strictly a Press reflex man and a master of that instrument. A reflex does more than take the guesswork out of focusing and assist composition. It allows the journalist photographer to choose the moment of tension when a winner is passing the post, and also moments of relaxation, when a subject has ceased to be self-conscious. It is also, of course, ideal for fast-moving subjects and general reportage. Thanks to PK's reflex, a forgotten motor race lives again: the 1906 Grand Prix du Littoral at Ostende (prints 45, 46, 47 and 48). The action shots are as good as anything in the motoring press of that period; and as always PK moves behind the scenes and captures the human interest. Drivers and passengers relax in their cars, those great British drivers Sir Algernon Guinness and his brother Kenelm Lee Guinness sip their victory champagne.

Ostende was a favourite resort for the PKs and visits here produced the beach scenes; the sand-yachts (prints 51 and 52), the Race of Spades (print 82), the hurdy-gurdy (print 44) and the kites (prints 72, 73, 74 and 75) – bourgeoisie, sport and low-life brilliantly combined.

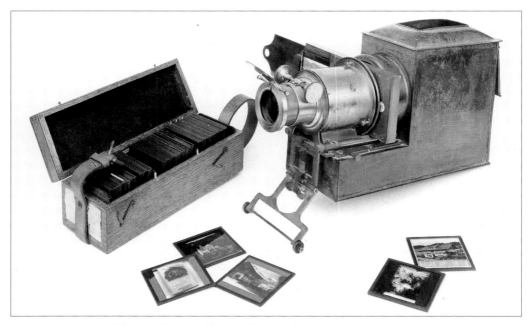

PK's own lantern slides and a typical 'magic lantern'

The negatives we have date from PK's freelance period. The photographs commence soon after 1900 and continue until 1911 when the family returned to England and settled at Riposo, Hastings. They begin again during the early 1920s when PK seems to have combined freelance journalism with holidays abroad. Many of the plates can be related to the published articles that we have traced in *Wide World*, etc. There is a final series, of mainly medical interest, documenting the Naturopathic work at Riposo. Several boxes of lantern slides, some made from his own photographs and others from the postcards of Schroth Cure resorts in Czechoslovakia, also survive. They were used frequently by both Andrew and Gordon, together with a carbon-arc magic lantern, to illustrate lectures about the work carried out at Riposo. The quality of the negatives, prints and slides is extraordinarily high. Andrew Pitcairn-Knowles was one of the great photographers of the dry-plate era, a master of the reflex camera and an excellent photojournalist.

The last letter to PK from his mother

36

The last, sad letter to PK from his mother, a few months before she died in Germany during the last year of the 1914-18 war

Andrew's mother died during the last year of the First World War having written on 11th September 1917 a last letter to the son she had not seen for so many years. James, the artist brother, deserted by his 'other half', the illegitimate daughter of Napoleon III, became depressed and went into a sanatorium an apparently broken man, only to recover and eventually marry Princess Louise Solms-Braunfels soon after his mother died. They lived in a castle at Hungen, north of Frankfurt. As an Englishman in Germany through another war, he was not interned, but restricted to his home in the castle. The town had cause to be grateful to him, and he is still remembered for saving it from devastation by shelling, when he walked across fields towards the advancing Americans, carrying a white flag and a Union Jack to say that the German army had left

the town. The sight of an 80 - year - old Englishman appearing in the front line must have been a surprise! He lived another ten years, to die in his castle in 1954. He, too, wrote some poignant last letters to his estranged brother, but we do not know if Andrew replied. But the interesting life of this artist brother, James, is a story of its own … for another time…

Andrew Pitcairn-Knowles died at home at Riposo, aged nearly 85, on 27th February 1956. His son, Gordon, survived only until 1963, and his wife, Margaret, until 1967, just before her 90th birthday.

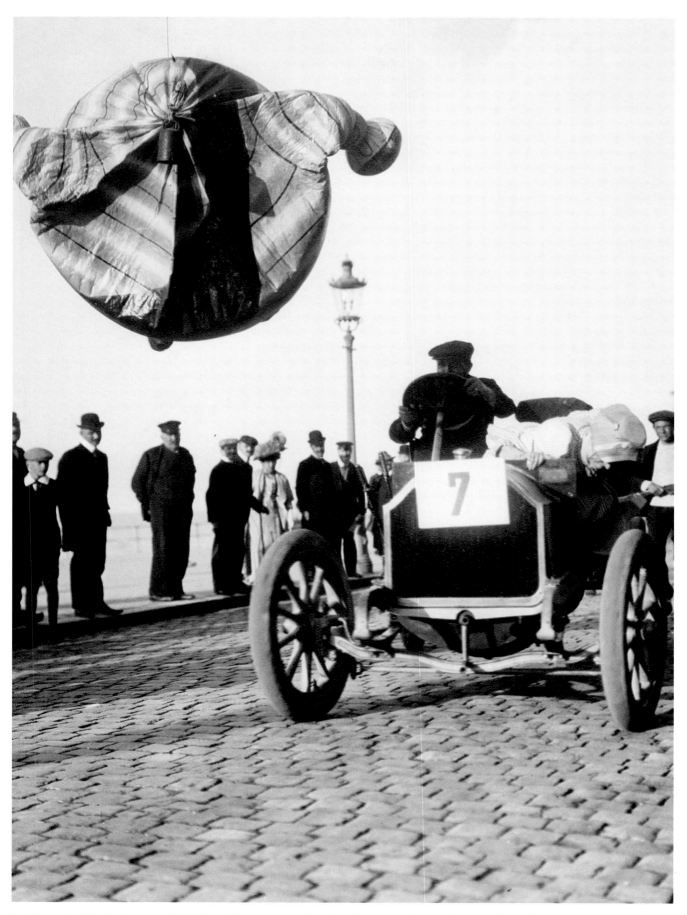

1. Ostend 1908, Automobile Gymkhana, the first in this selection of 110 prints chosen from over 1000 Andrew Pitcairn-Knowles photographs.

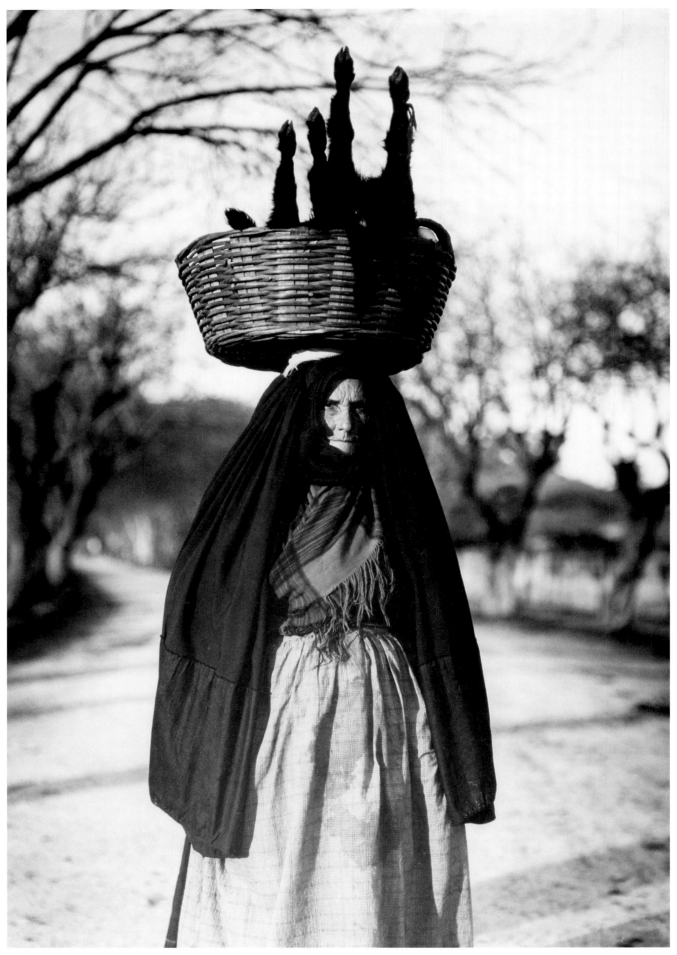

2. Carrying the kid to market - Corsica - c1903. Andrew Pitcairn-Knowles took his wife and very young son to Corsica around 1903 to cover articles about goats, hunting and bandits. The goats he photographed in detail but for his article on the bandits he used borrowed photographs as he was not allowed near enough to 'snap' them!

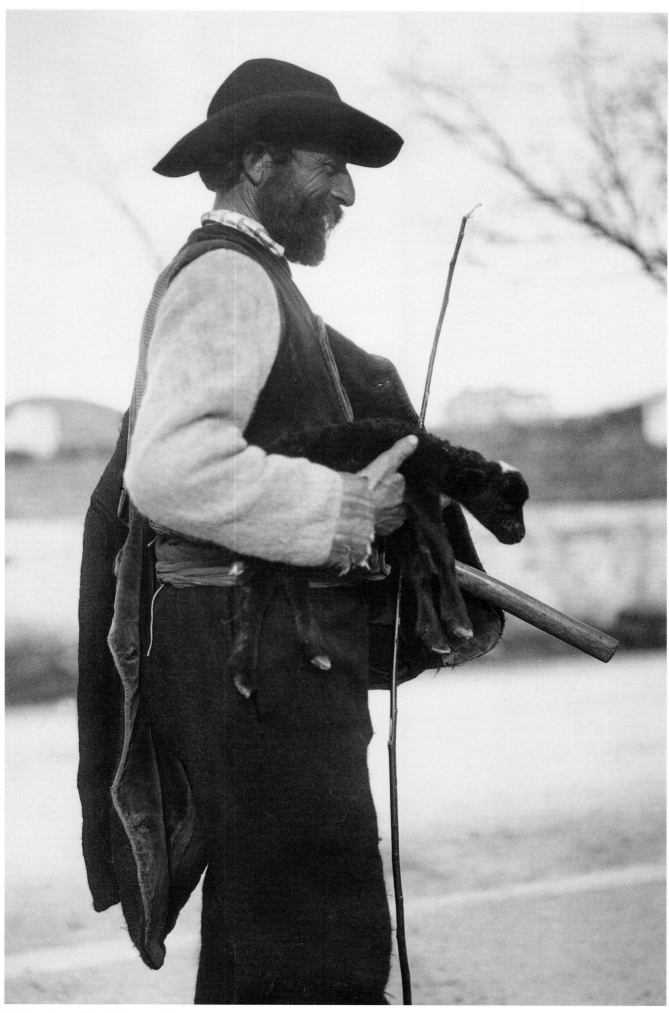

3. Carrying a live kid to market.

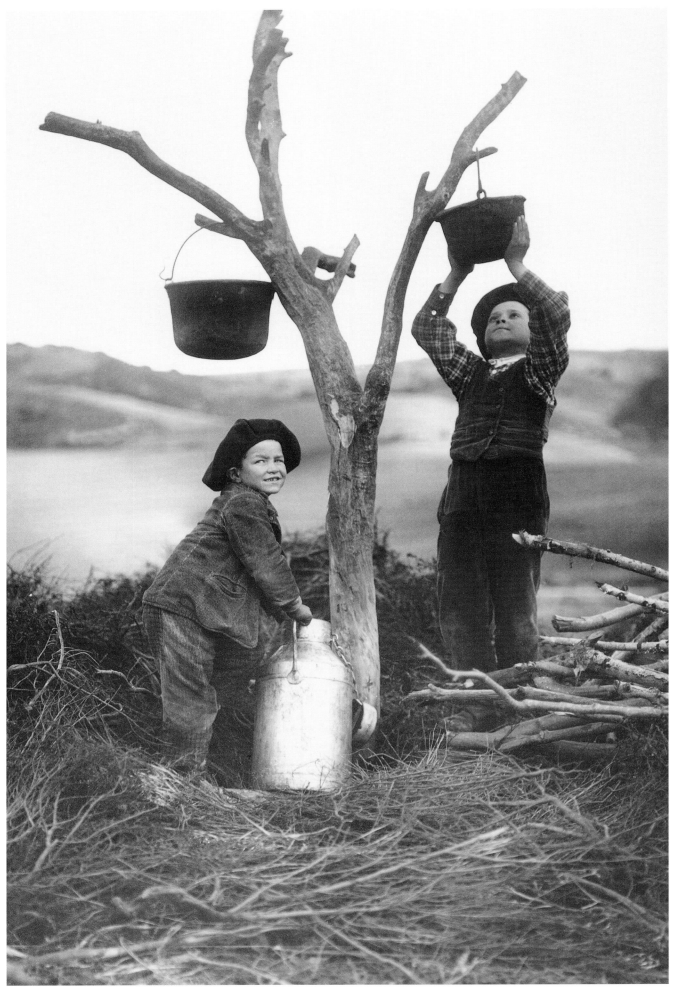

4. The goats milk tree - Corsica. To keep the milk away from the goats and insects, pails were hung high up on branches.

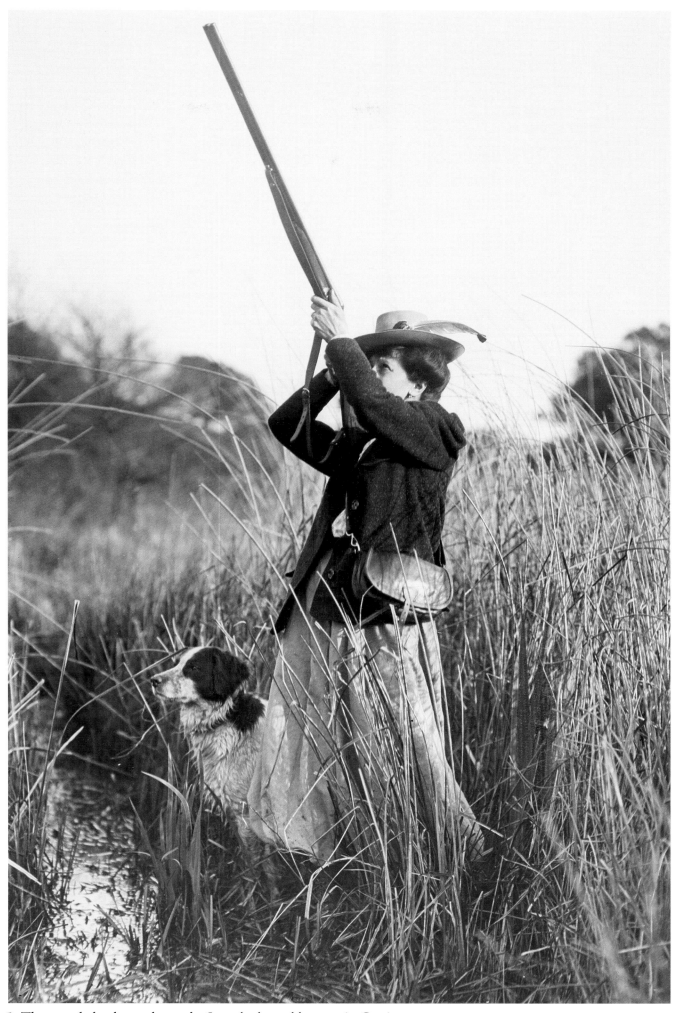

5. The muzzle loader at the ready. Smartly dressed hunters in Corsica.

Pumpkins - Nice - c1909. The July 1910 issue of *Wide World* magazine contains an article including these photographs: *'The Pumpkin Festival - An account of an ancient festival which - greatly altered in character and significance - has been resuscitated at Nice. Pumpkins of all sorts and sizes figure largely in the celebrations, as do the eating of pancakes and much dancing and merry-making, while the old-time religious associations of the day are not forgotten.'*

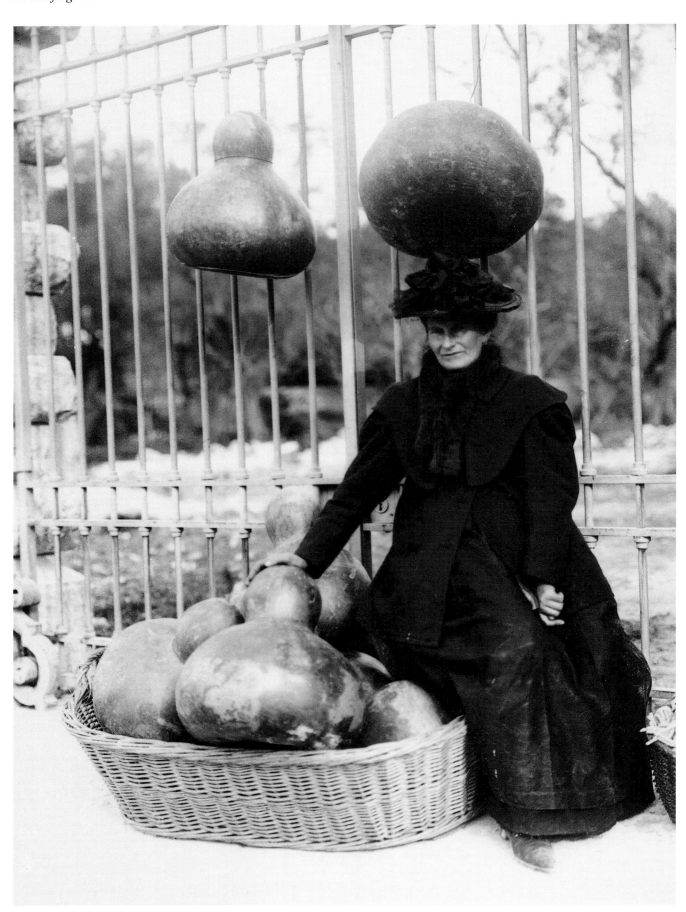

6. *'Vendors of pumpkins, many of whom have trudged weary miles with their burdens, have taken up their stand around the walls of the cemetery and spread out their wares in picturesque array.'* (Wide World *article*)

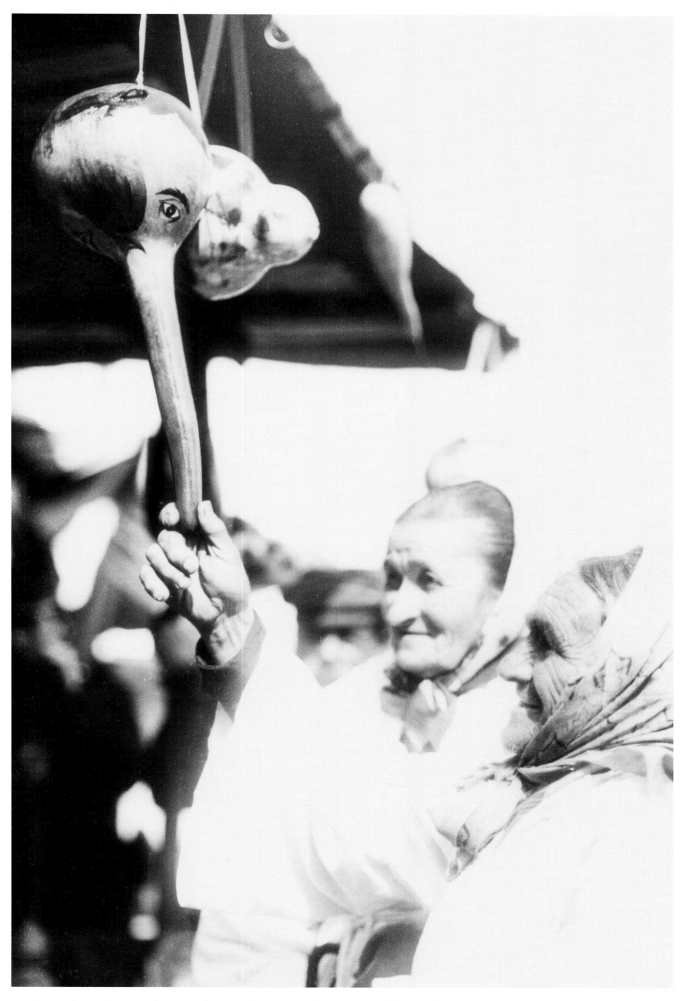

7. 'Pumpkins of every shape and size, form and colour, are exhibited, from rudely decorated specimens to those bearing the handiwork of the skilled artist.' (*Wide World* article)

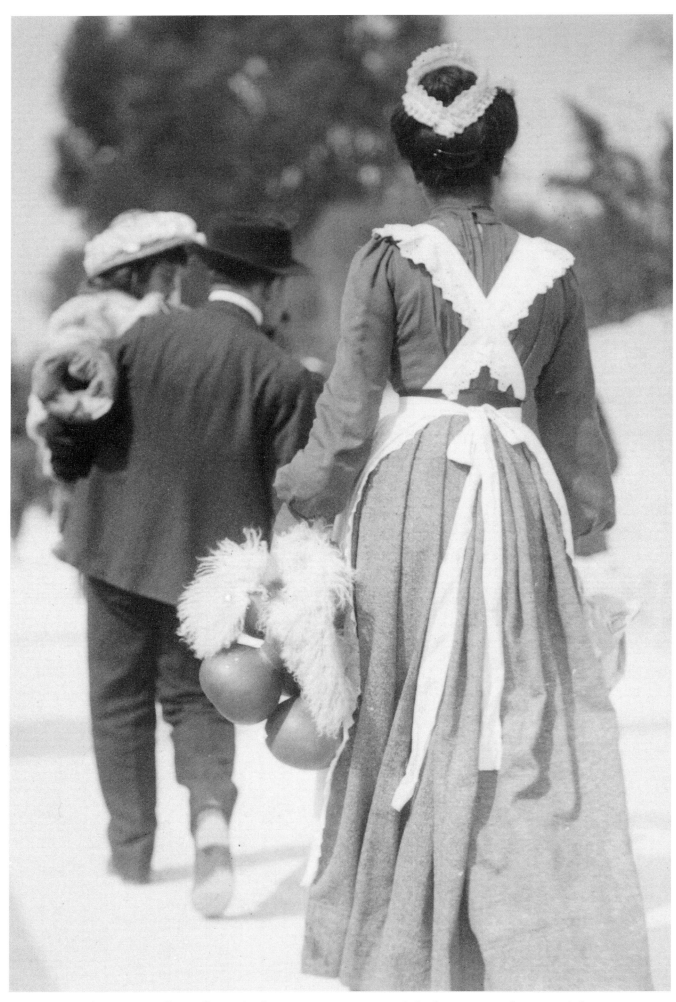

8. '*The crowd is continually swelling, the late comers, consisting of the bourgeoisie of Nice and foreign tourists, having joined the throng of early risers.*' (*Wide World* article)

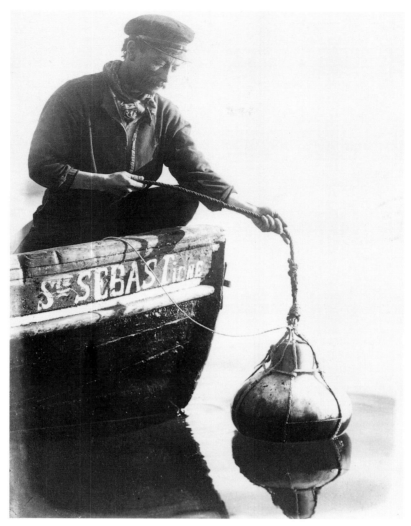

9. A pumpkin used as a mooring buoy

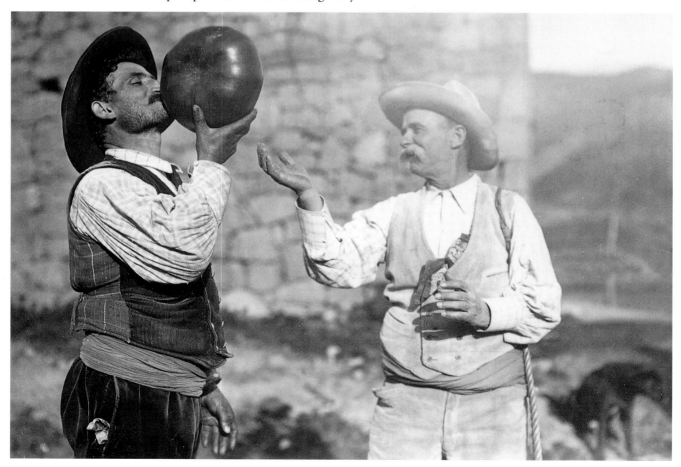

10. Many pumpkins are dried and used as drinking bottles

Fish - The series on the fishmarkets of Grimsby and Ostend shows the landing, handling and auction of fish

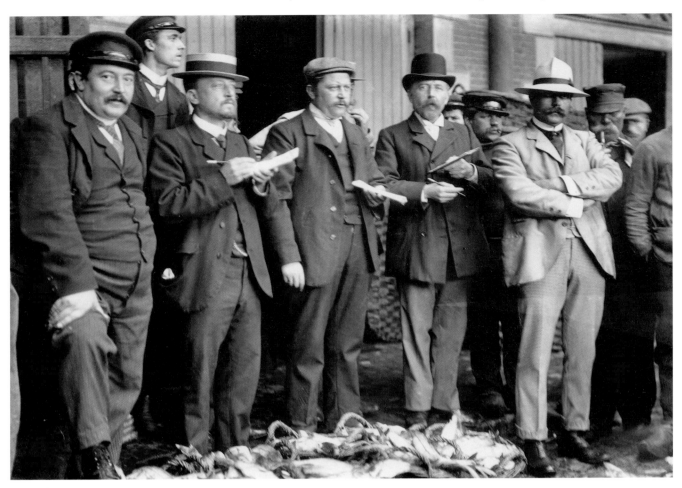

11. Fish Auction

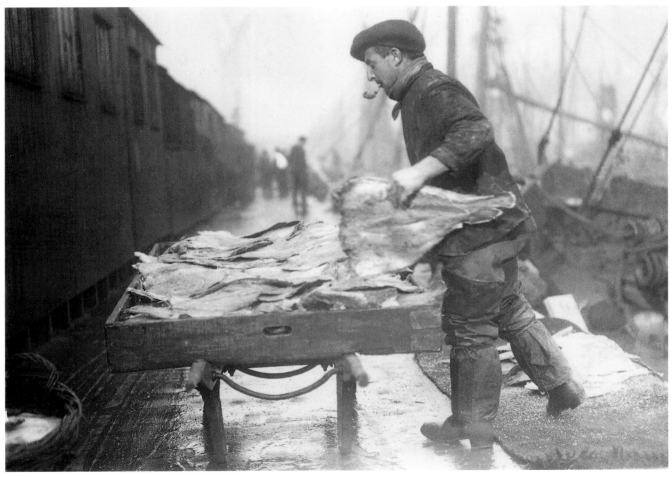

12. The Catch

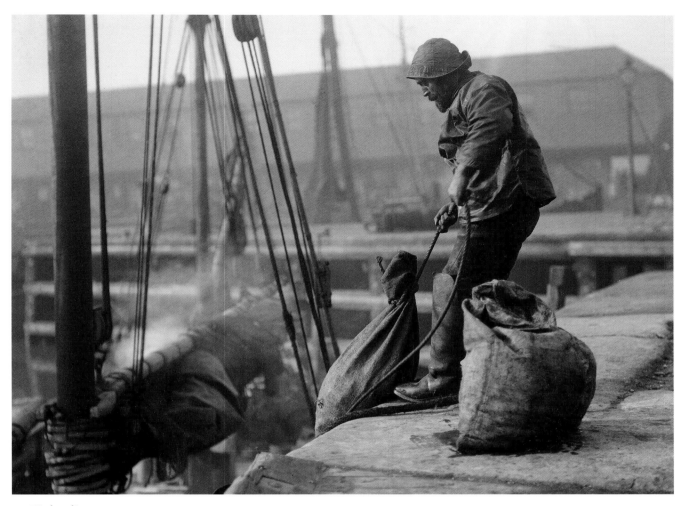

13. Unloading

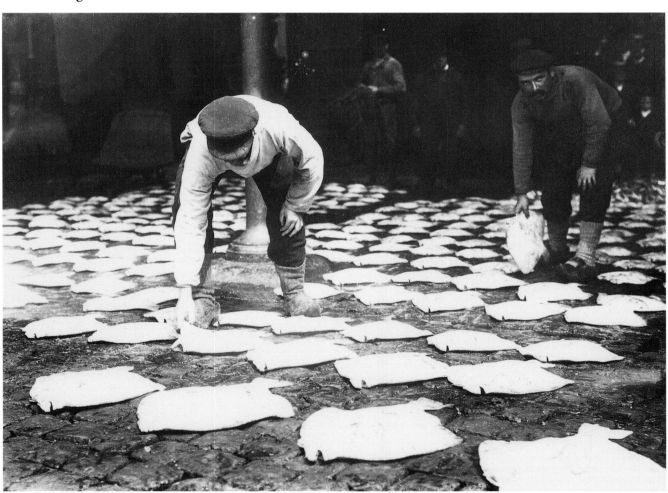

14. Fish Market

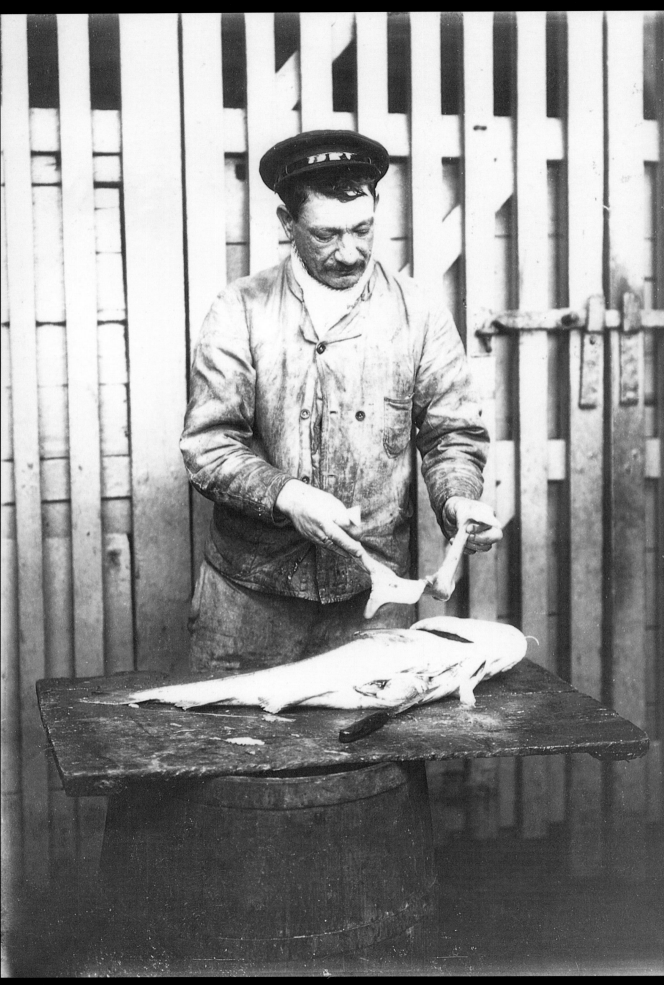

15. Cods' livers removed

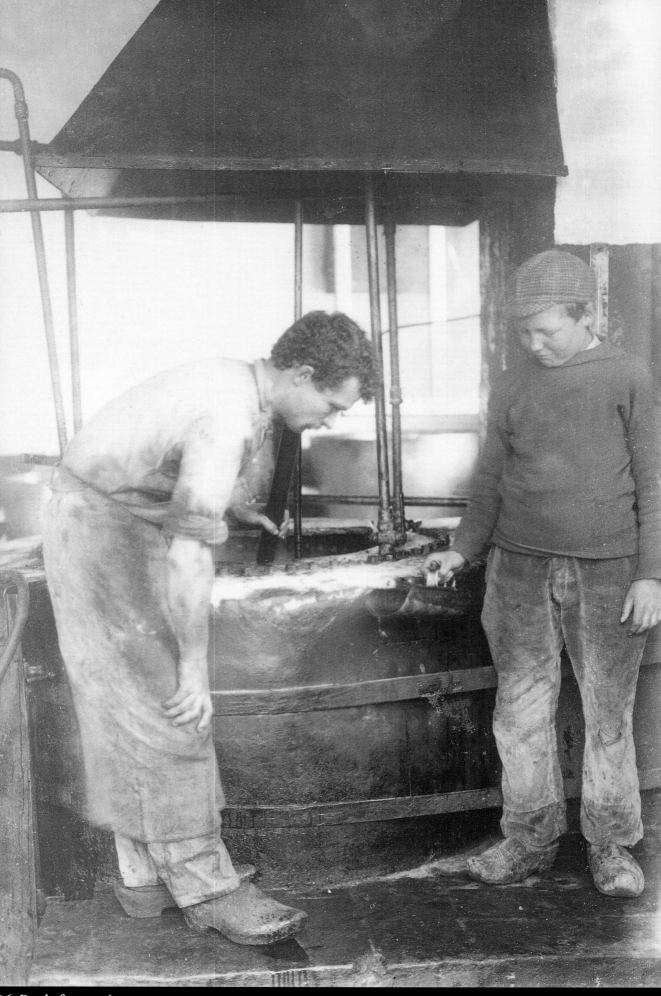

16. Ready for pressing

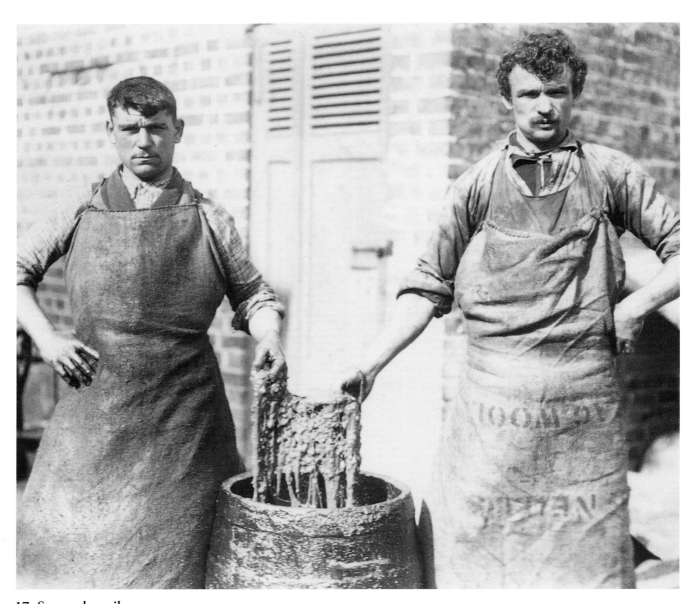

17. Steamed to oily mess

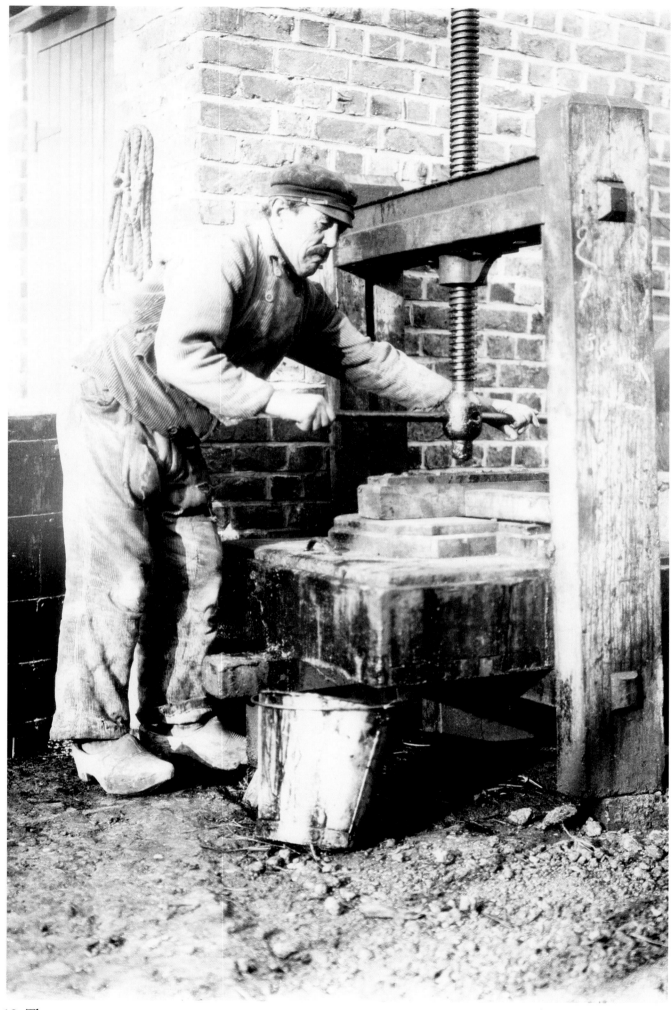

18. The press

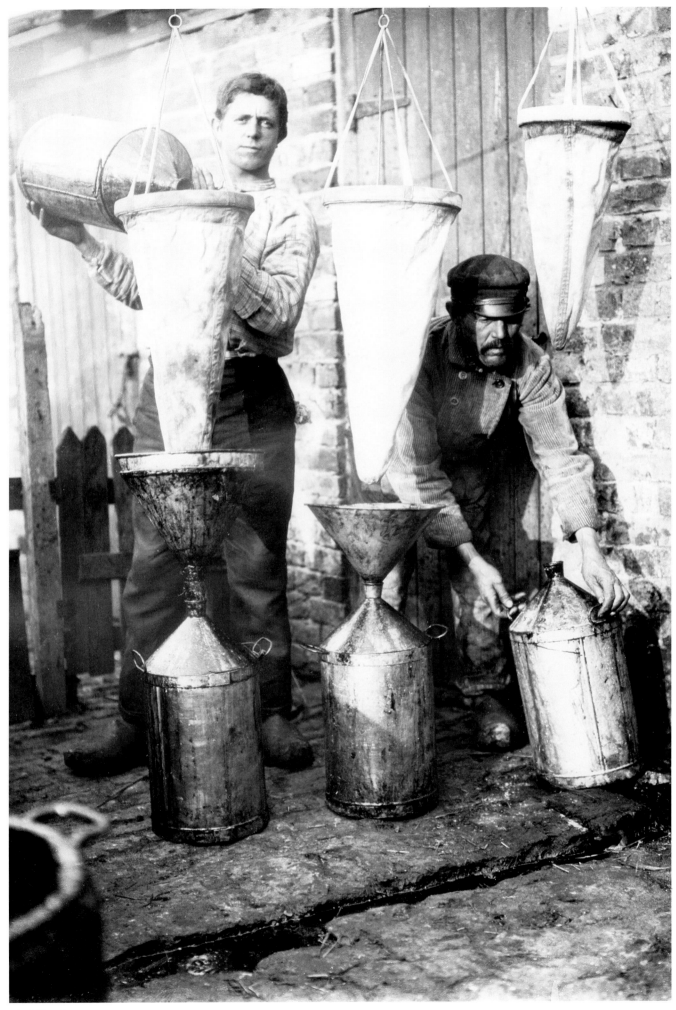

19. Filtering

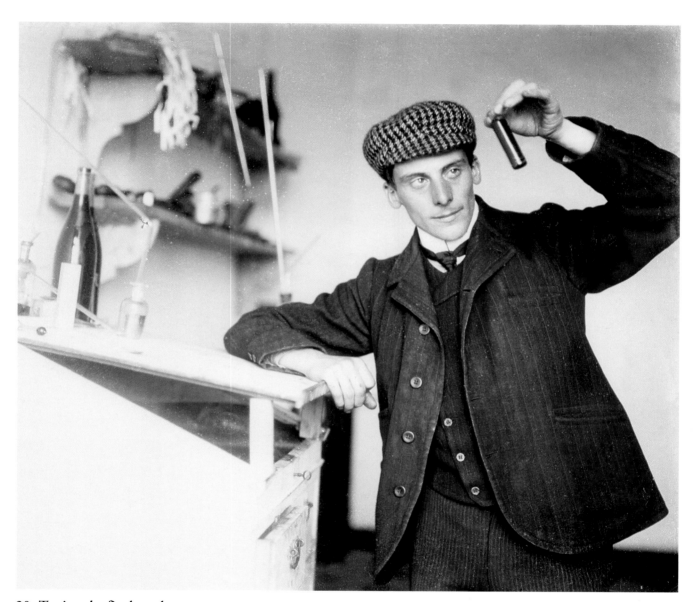

20. Testing the final product

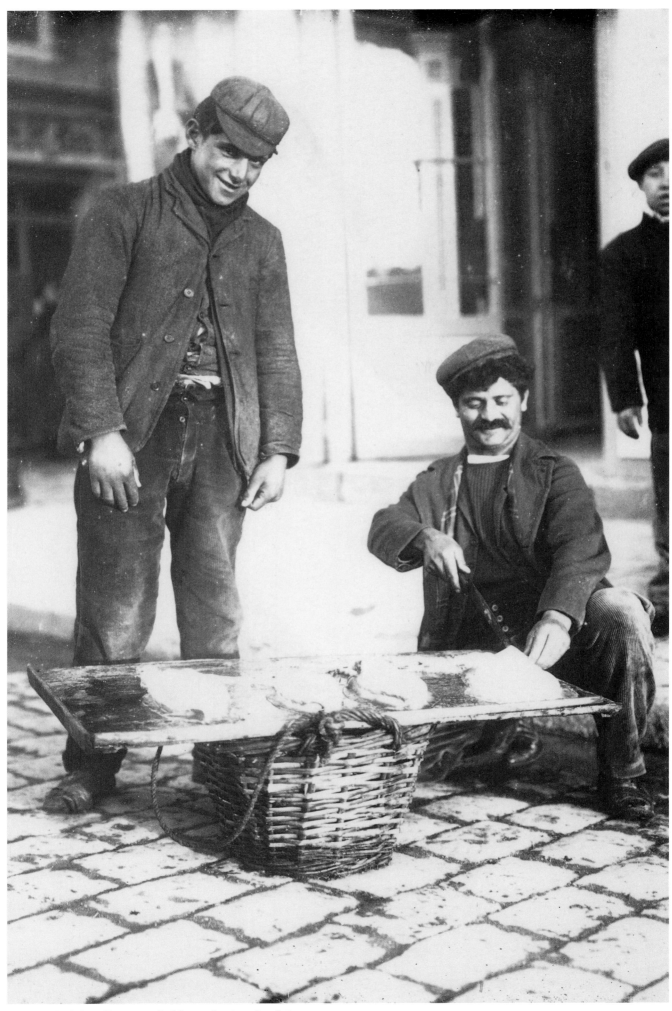

21. Cuttle fish sellers - probably in the South of France

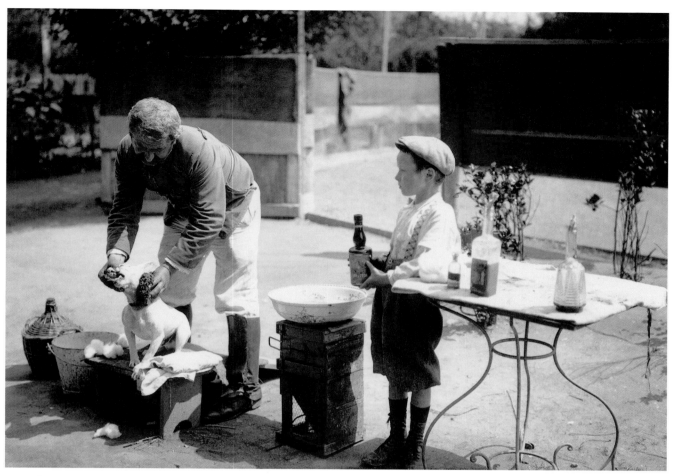

22. The Ratodrome - 'Hospital for the bitten dogs'

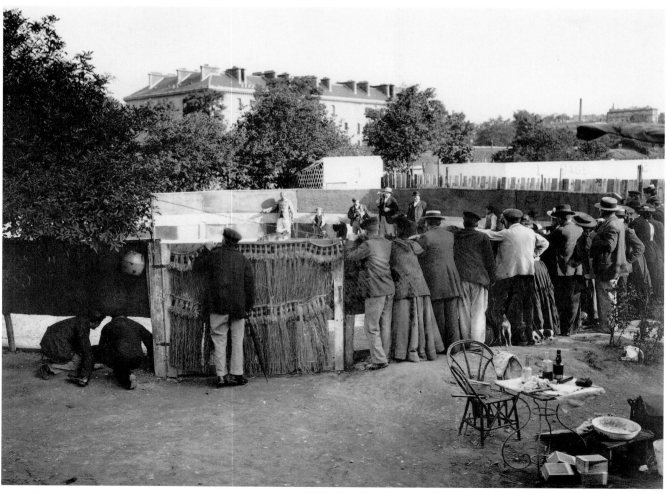

23. The Ratodrome

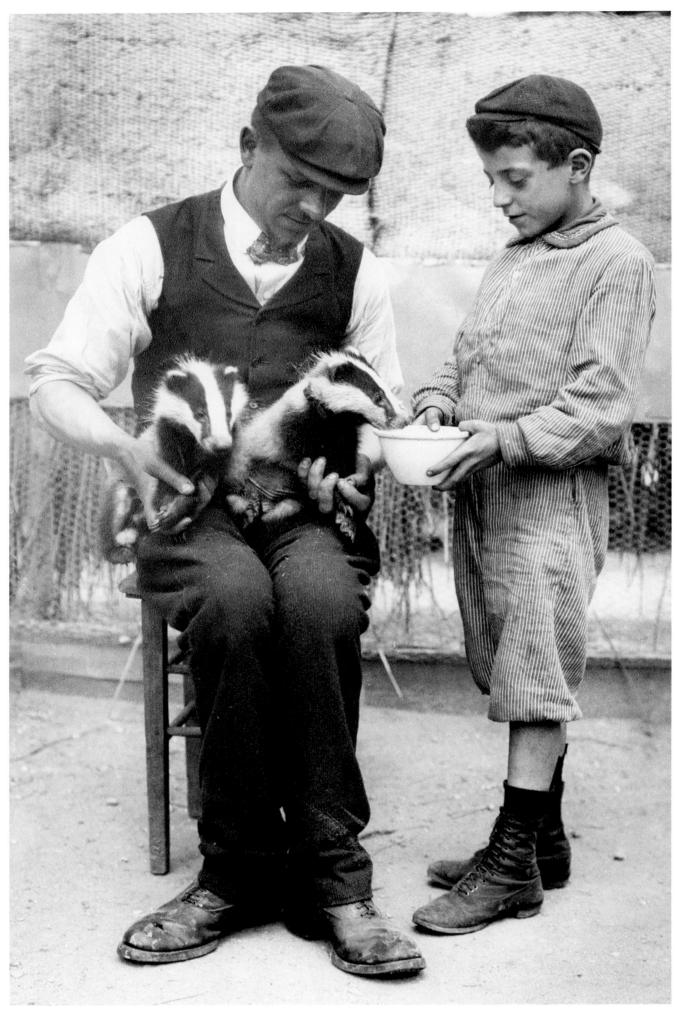

24. Badgers - kindness to the badgers?

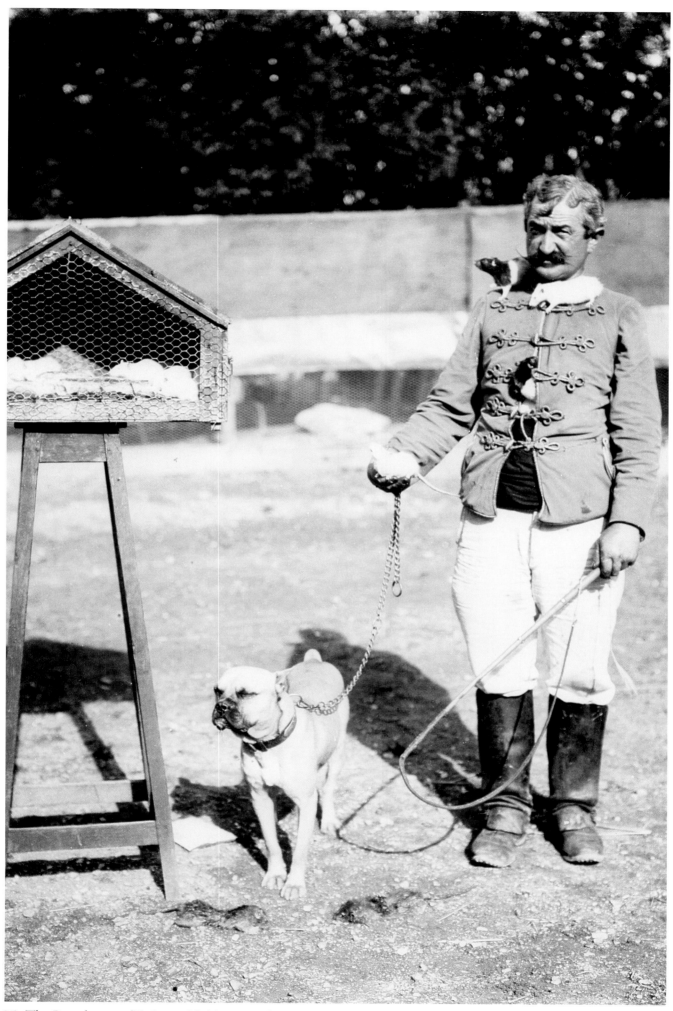

25. **The Ratodrome** - 'Trainer with his pet rats'

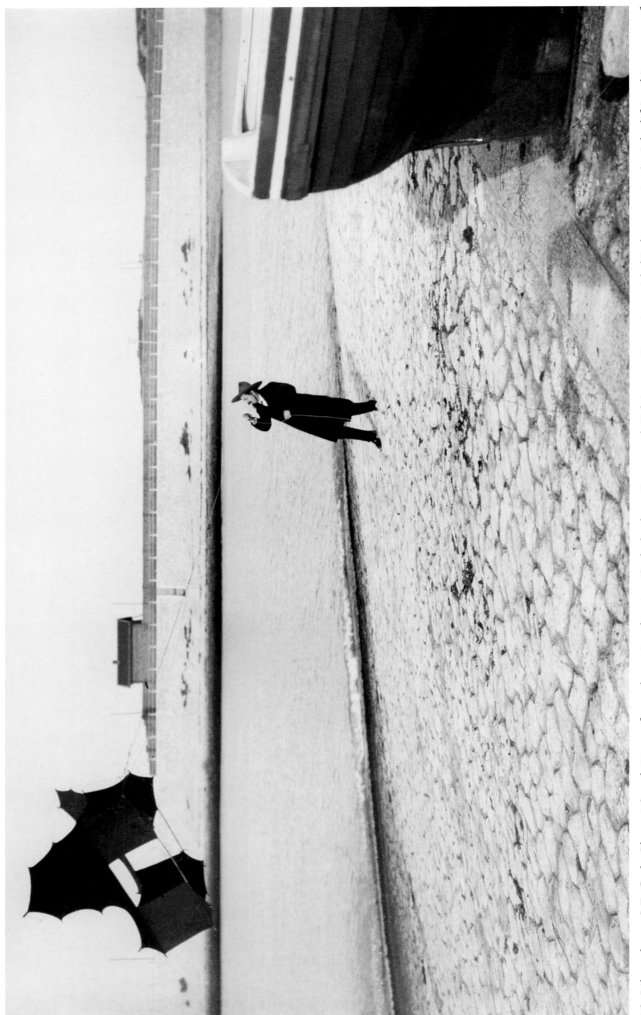

26. **Like a bat** – S.F. **Cody** Plates 26 and 27 are from the series showing Cody both at Dover and Calais experimenting with his boat towing/weight-lifting kites, one of which successfully towed him across the channel.

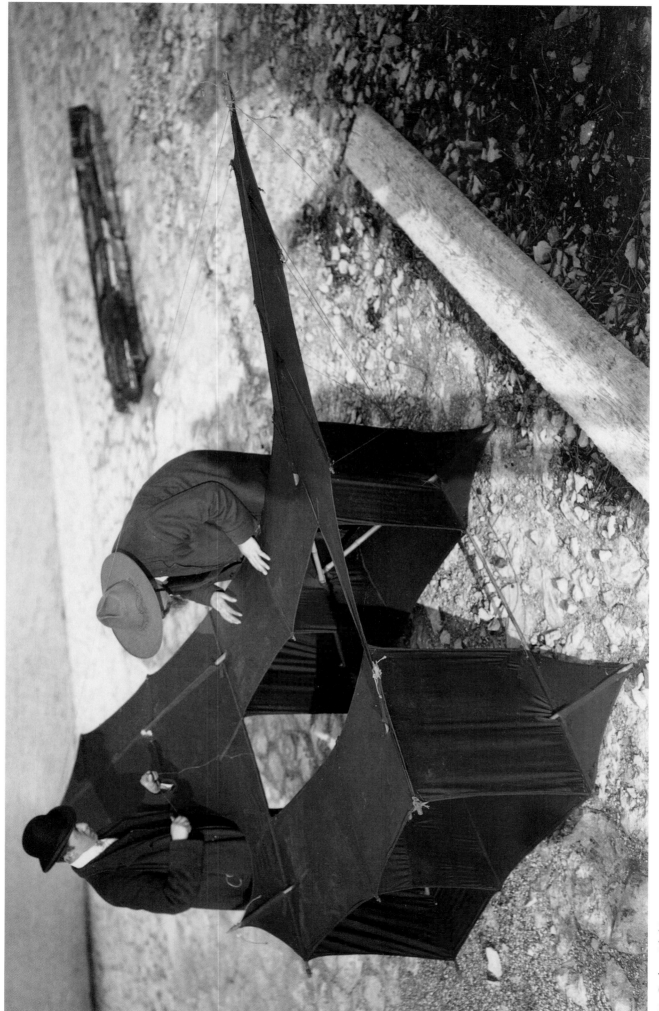

27. Cody with kite

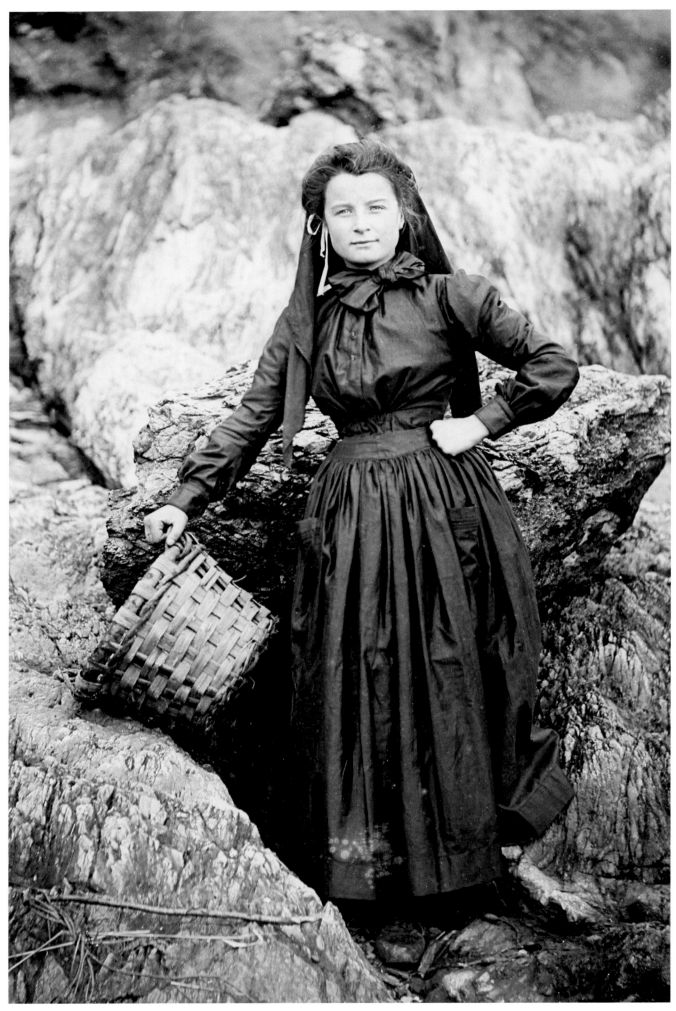

28. Oyster Girl - somewhere in France? Concarneau?

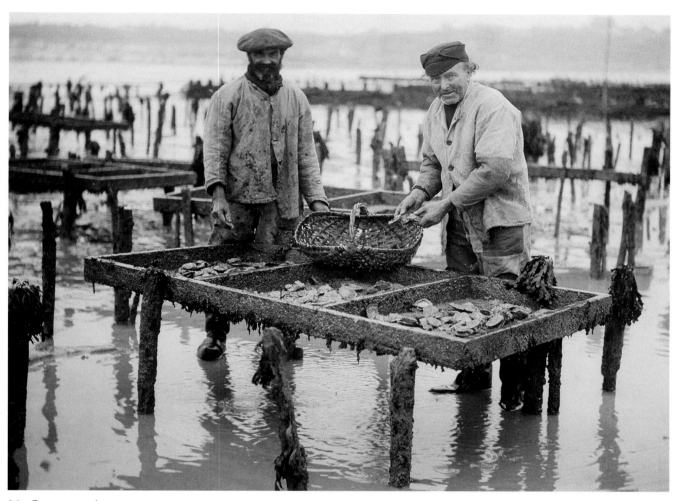

29. Oyster sorting

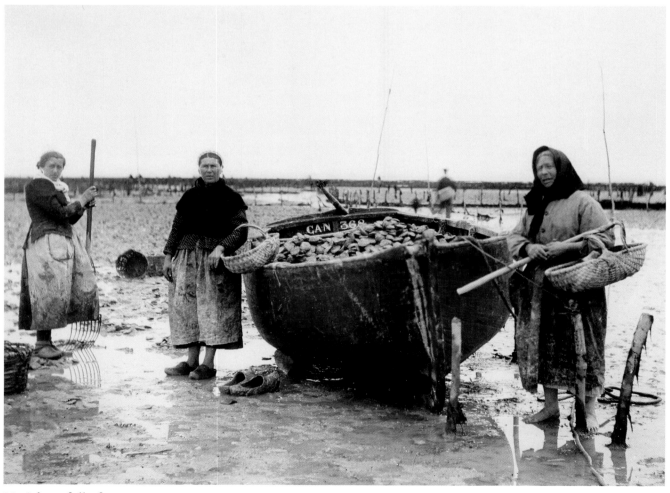

30. A boat full of oysters

Lobster farming c 1900 Hummernpark

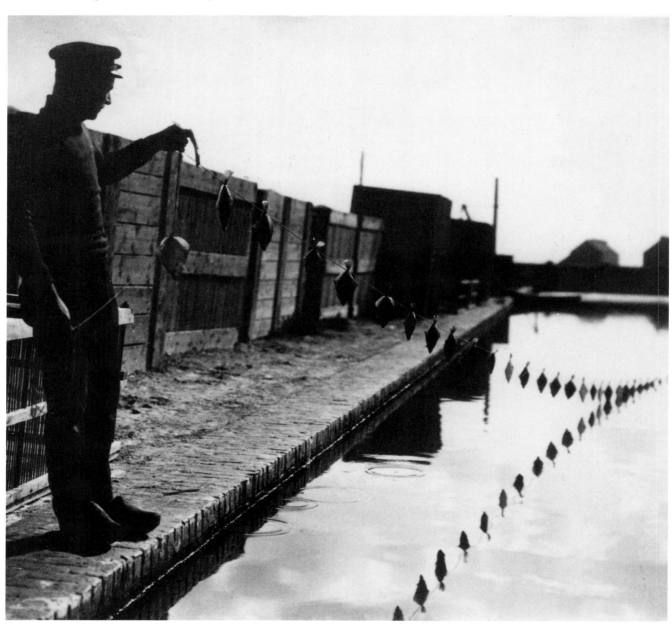

31. Food for lobsters on the lobster farm

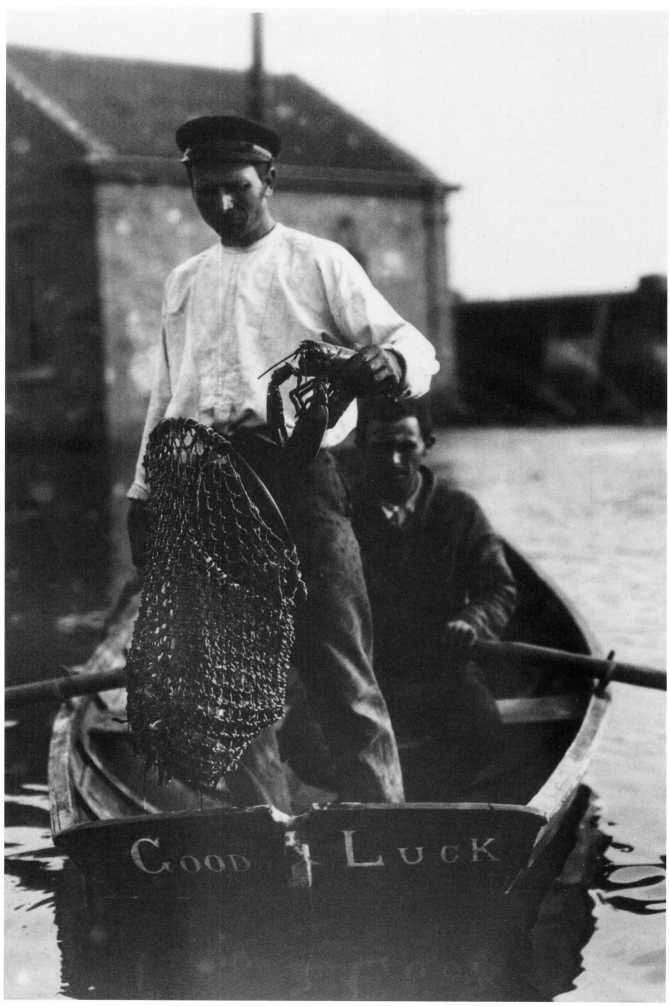

32. Harvesting

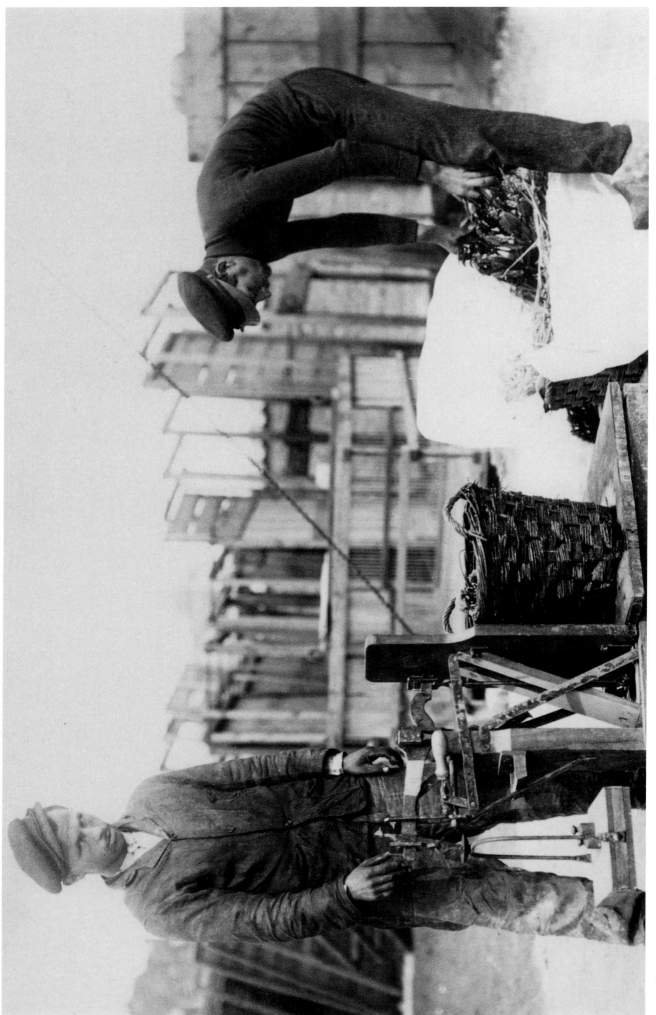

33. Lobsters by the kilo

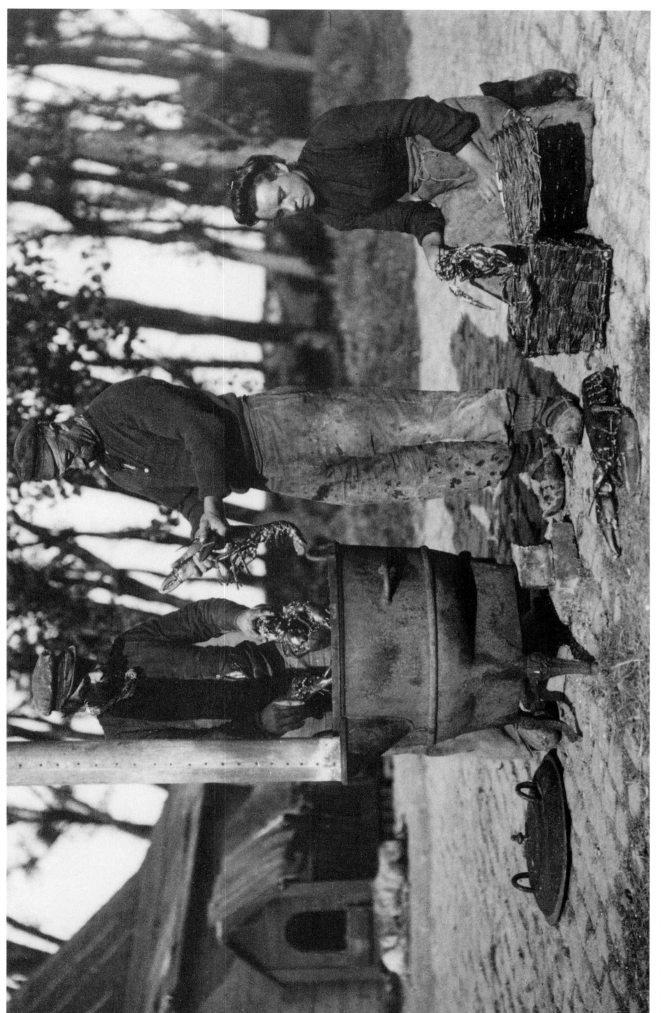

34. Outdoor kitchen!

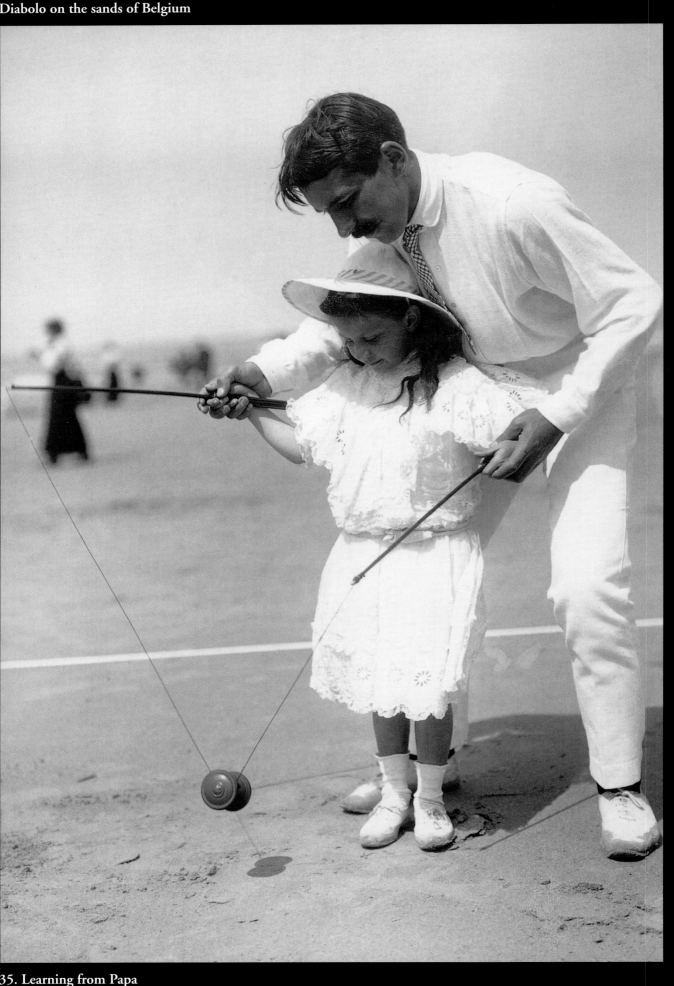

35. Learning from Papa

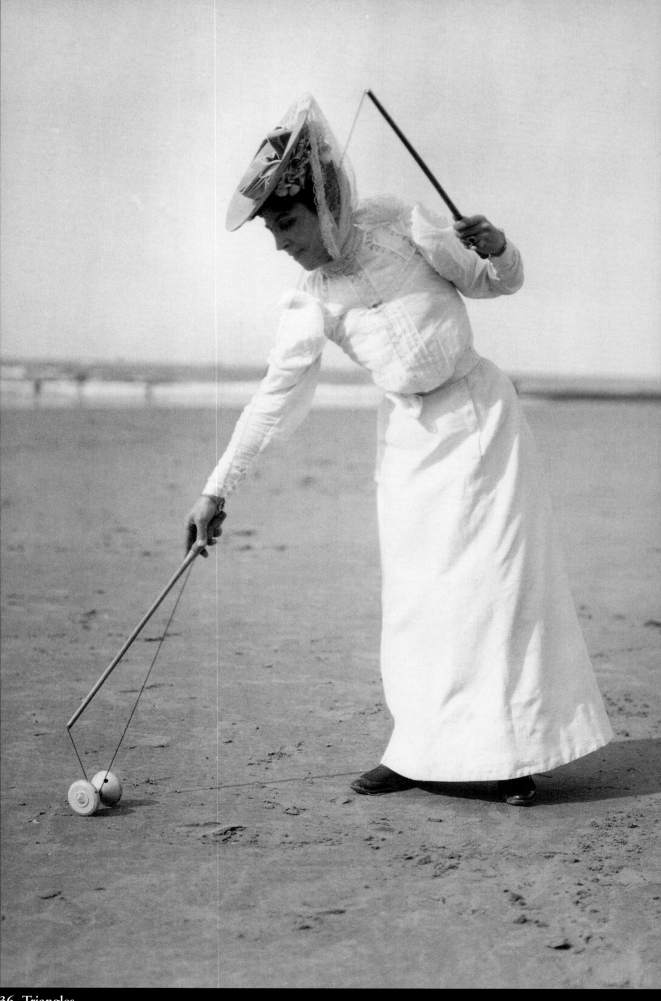

36. Triangles

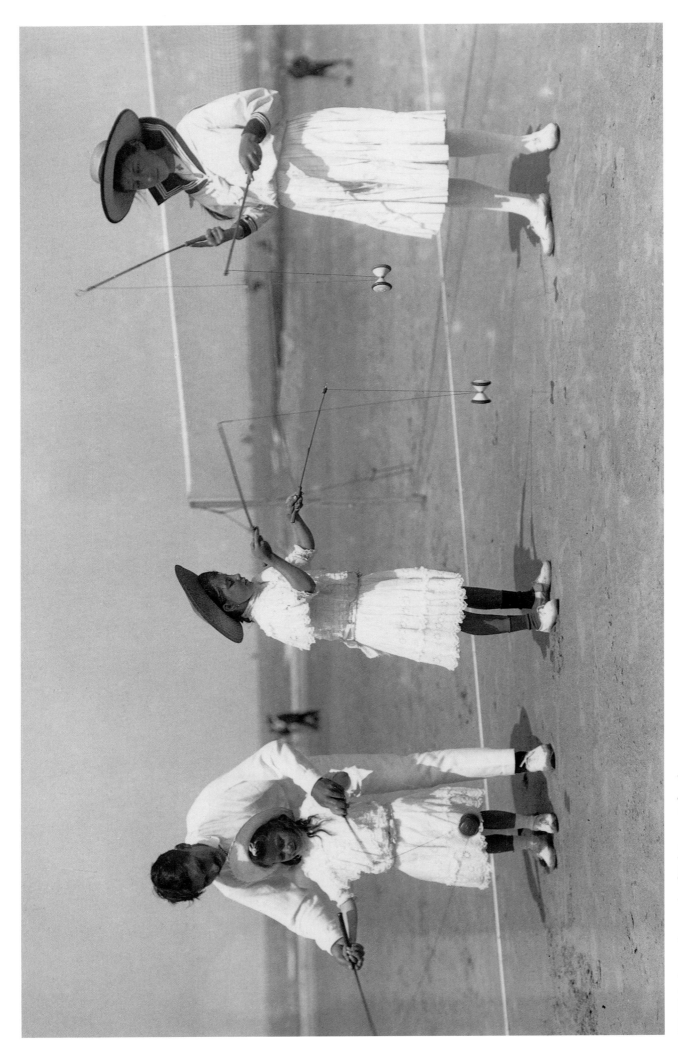

37. Diabolo on the sands of Belgium - A family game

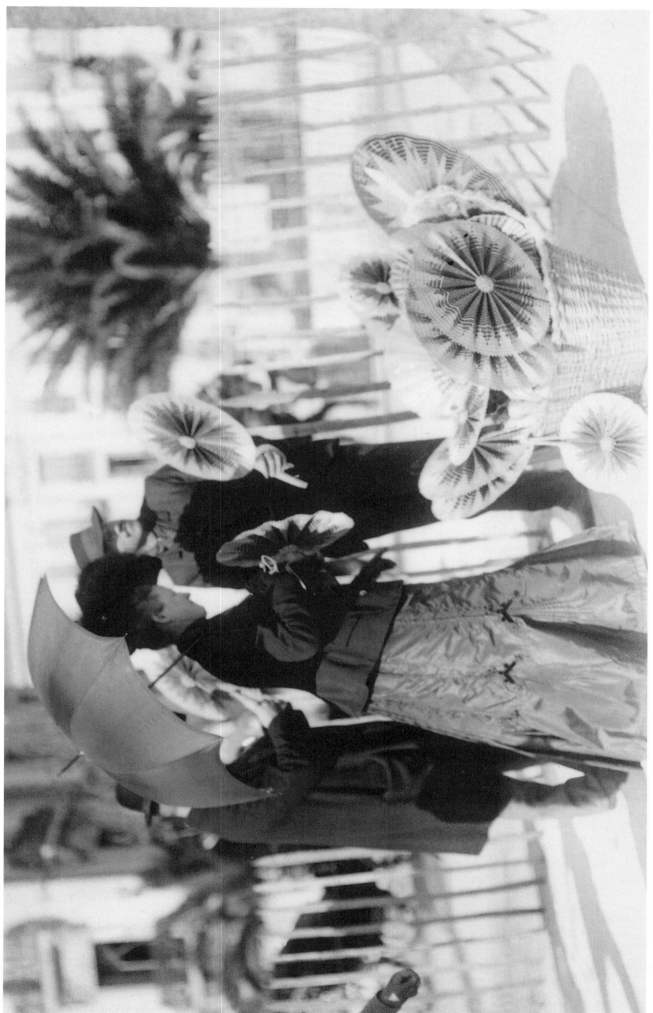

38. French Riviera - keeping cool

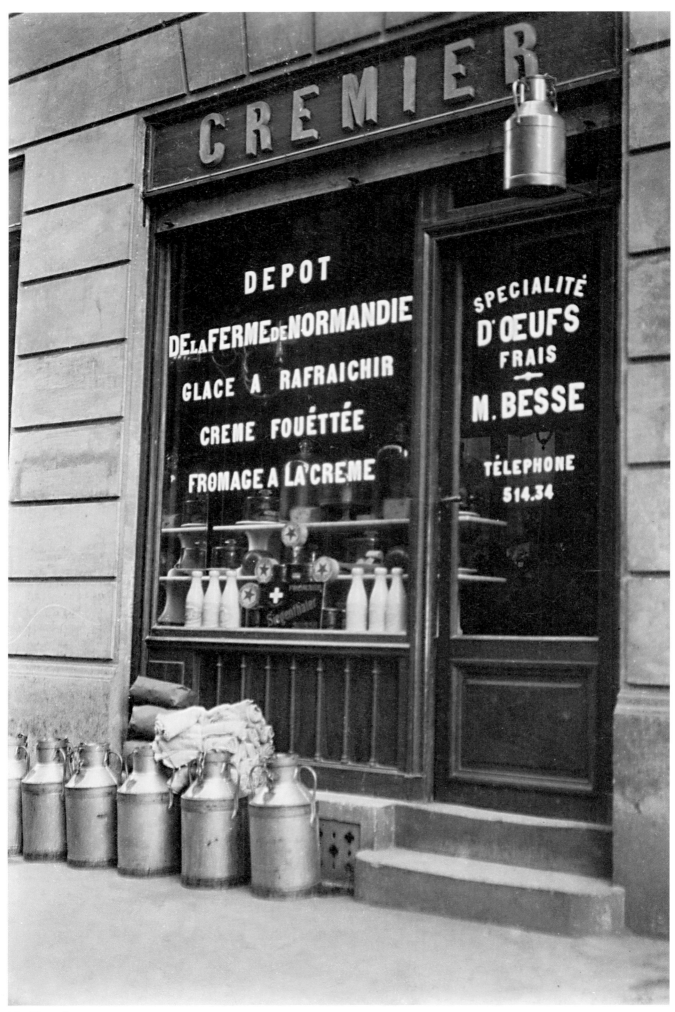

39. Shop front

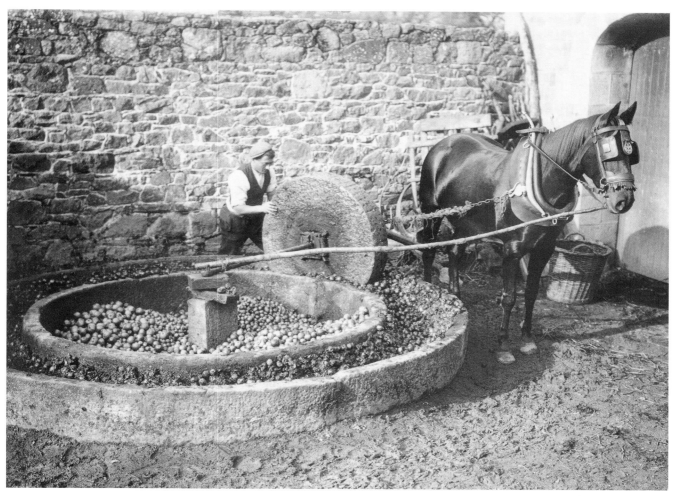

40. Cider making, Brittany? - Apples under the millstone

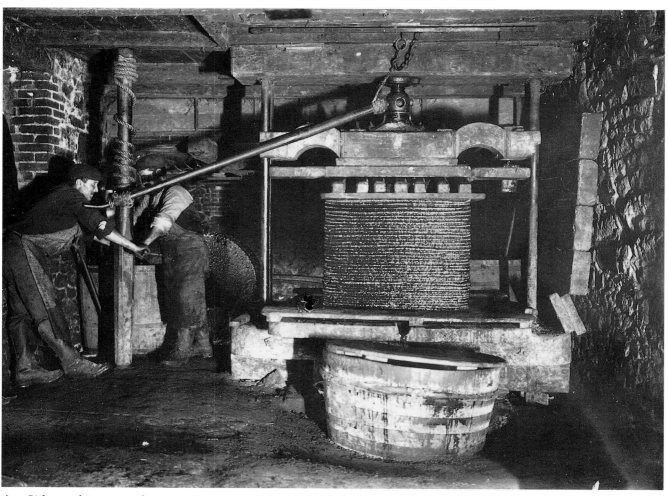

41. Cider making - Final press

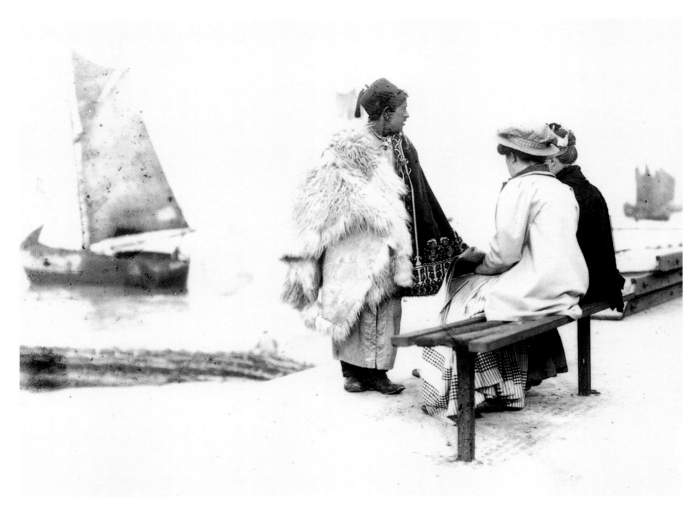

42. **'Auf der digue'** - On the sea front, Belgium - carpet seller

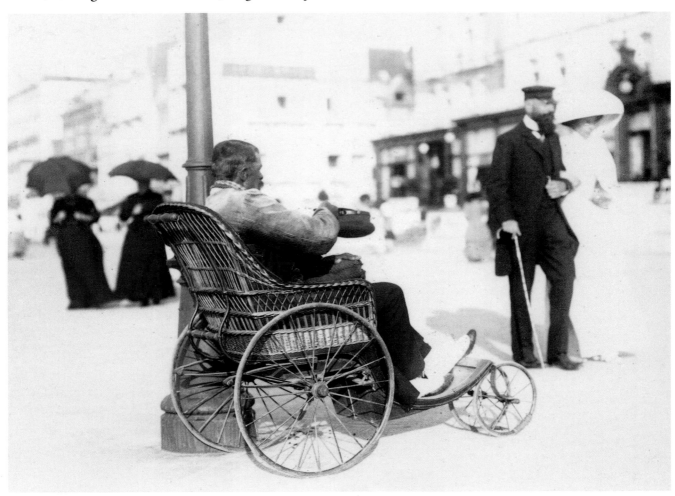

43. **'Auf der digue'** - Bath chair

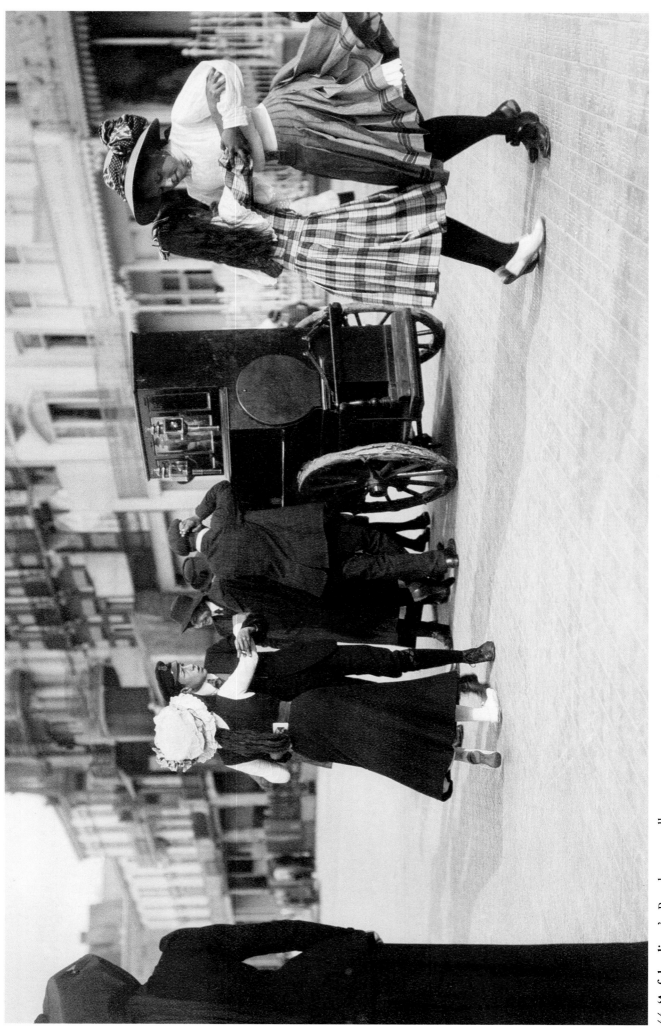

44. 'Auf der digue' - Barrel organ polka

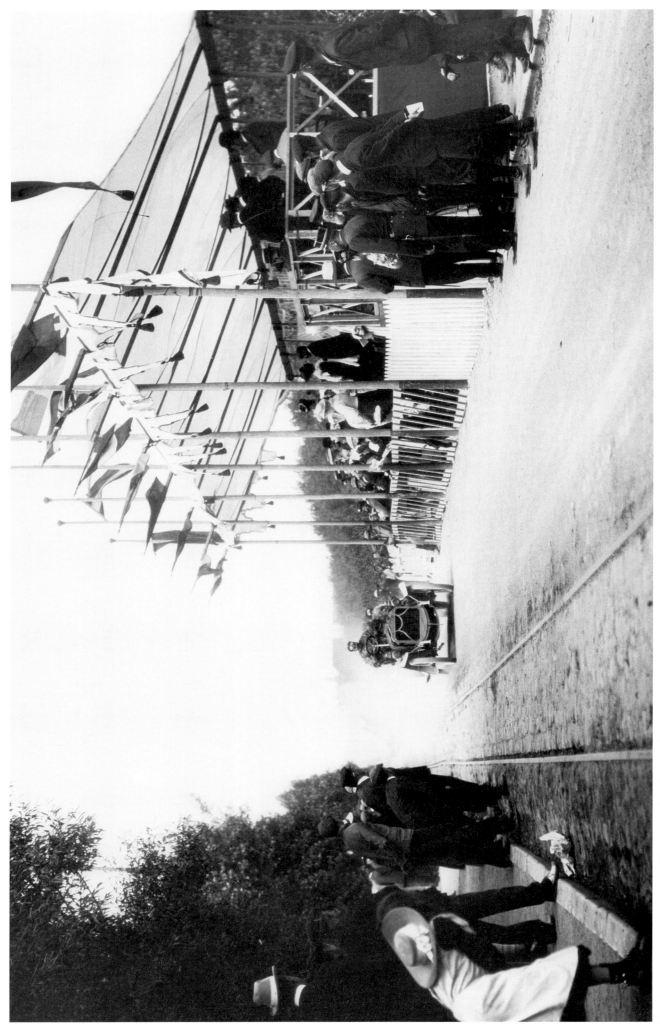

45. **Race in progress Circuit du Littoral and Grand Prix racing - Ostend 1906**

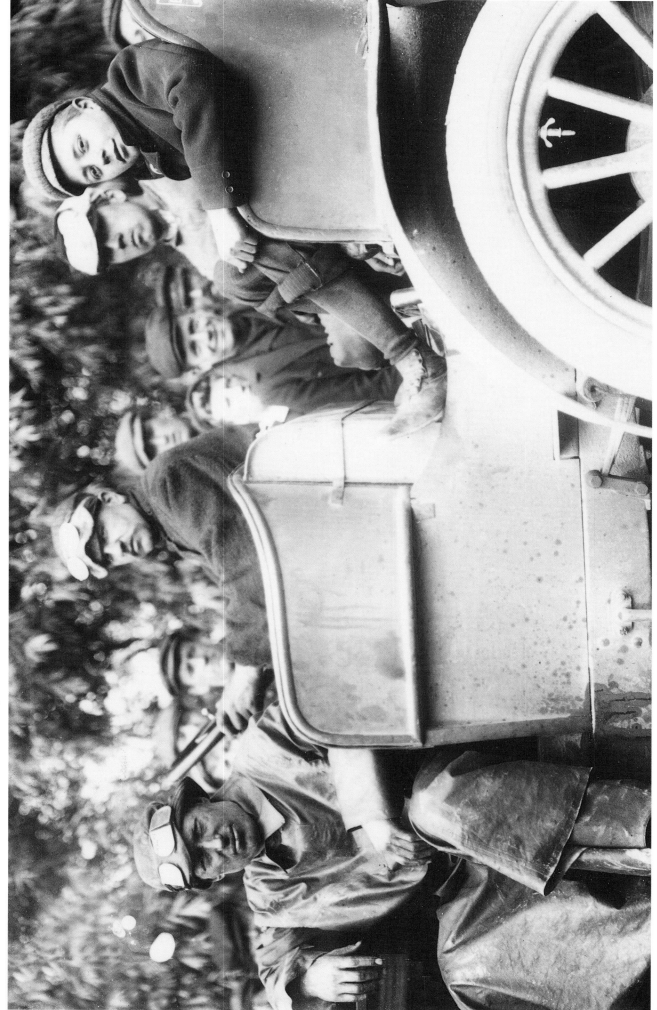

46. P.K's writing on the reverse of the original print: 'The German Wilhelm who came in first in the splendid time of 4 hrs 27 mins 32 secs in a Belgian car.'

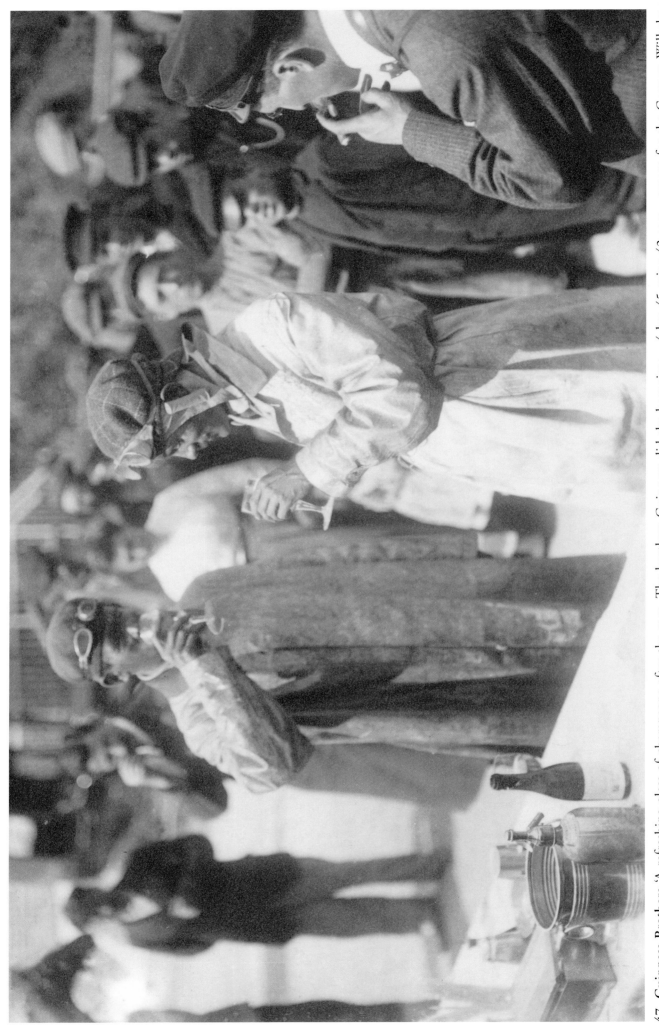

47. **Guinness Brothers** 'A refreshing glass of champagne after the race. The brothers Guinness did the best time - 4 hrs 45 mins 42 secs - except for the German Wilhelme who, however, was "hors-serie" '

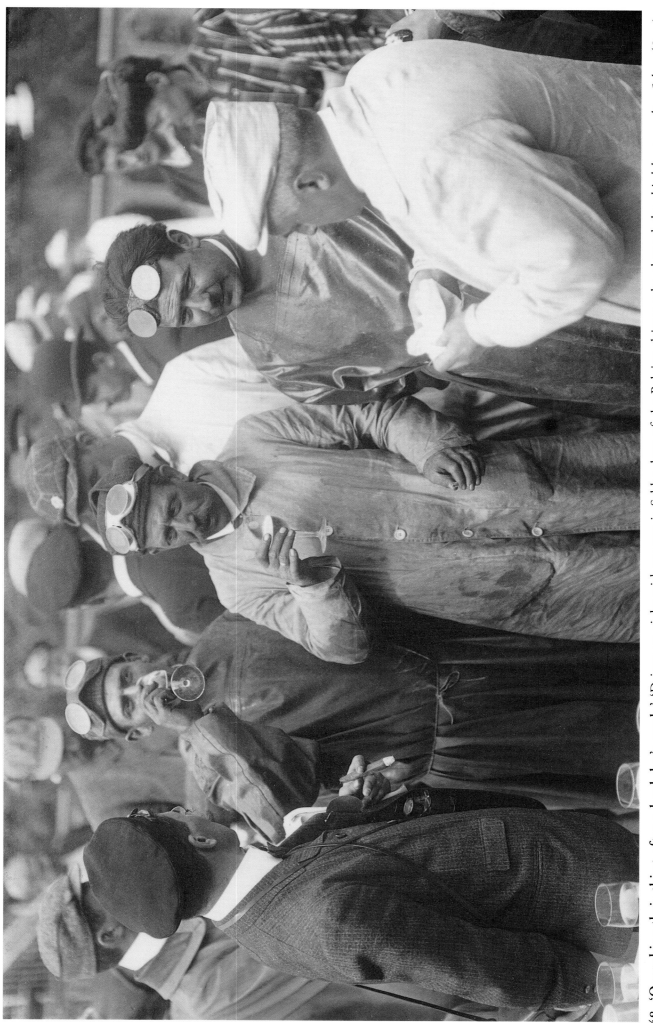

48. **'Quenching their thirst after a hard day's work.'** 'Driver on right without cap is Sabbe, best of the Belgian drivers who showed the third best result - 5 hrs 48 mins 46 secs.' Copied from P.K's writing on the back of original print

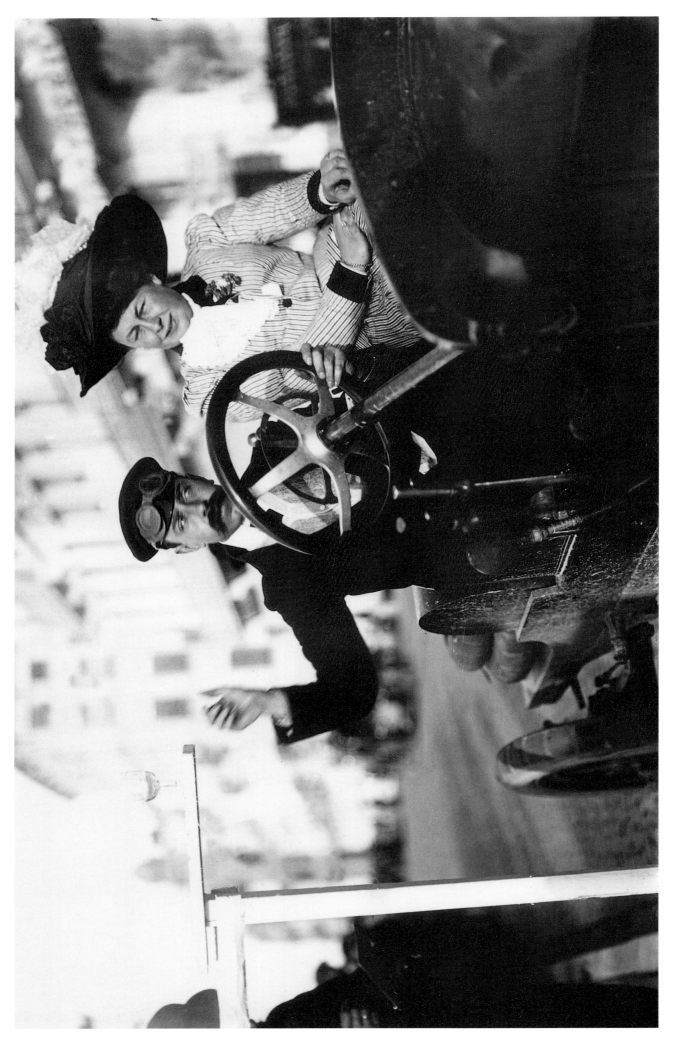

49. Automobile Gymkhana - Ostend 1908 - Driving/drinking?

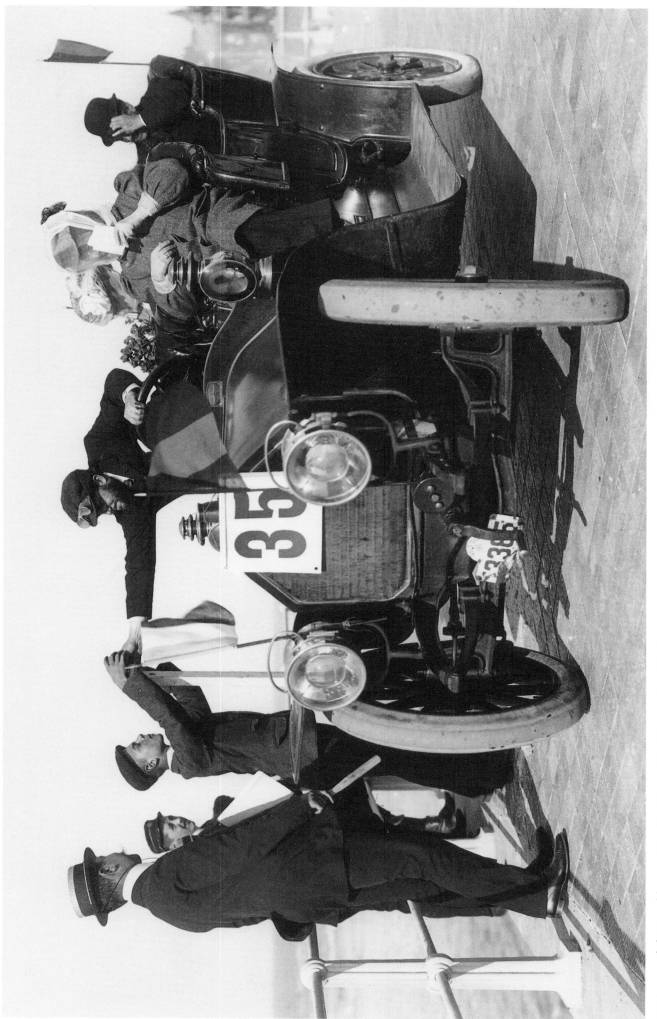

50. Automobile Gymkhana - Number 35 reaching for another drink!

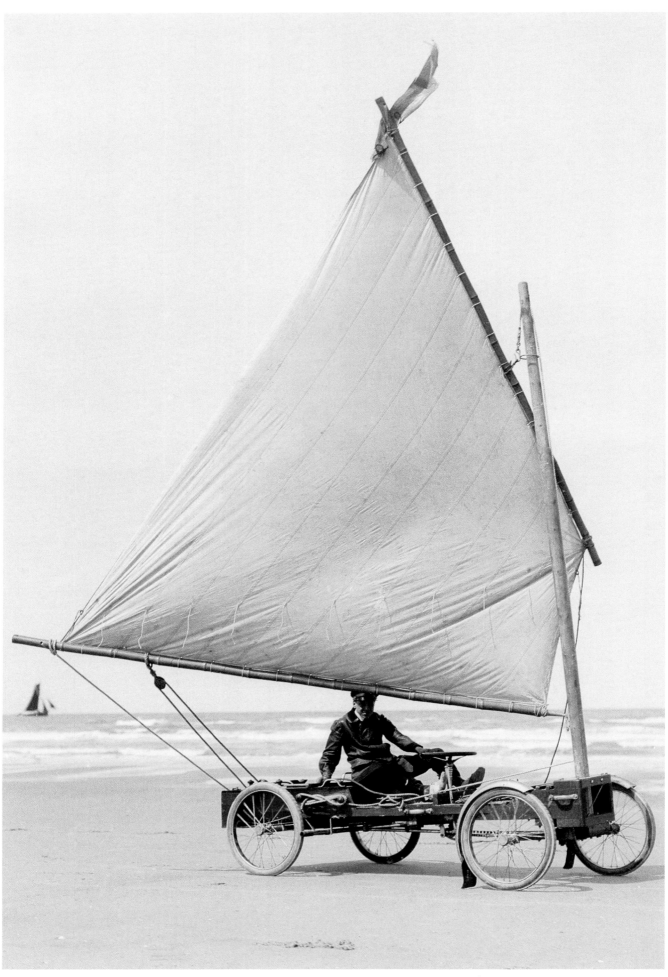

51. Sandyachting - 'Sailing machine going with the wind'. Six from the series of sixteen photographs, of which this is one, were used to illustrate the article 'Sailing on Terra Firma by A. Pitcairn-Knowles (with photographs by the Author)' which appeared in the August 1908 issue of *The Badminton Magazine*.

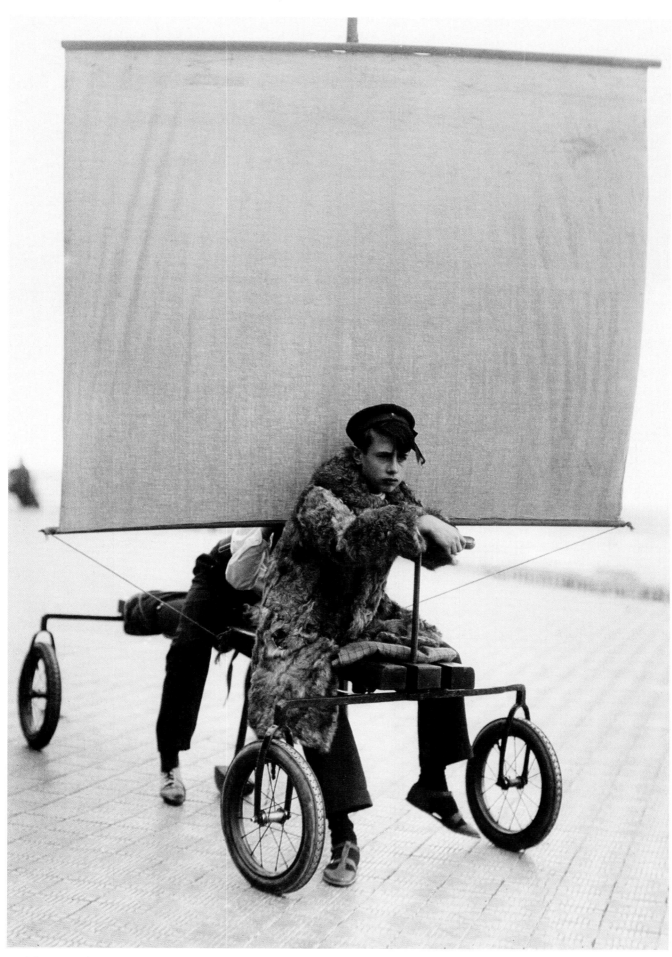

52. **Young enthusiasm**

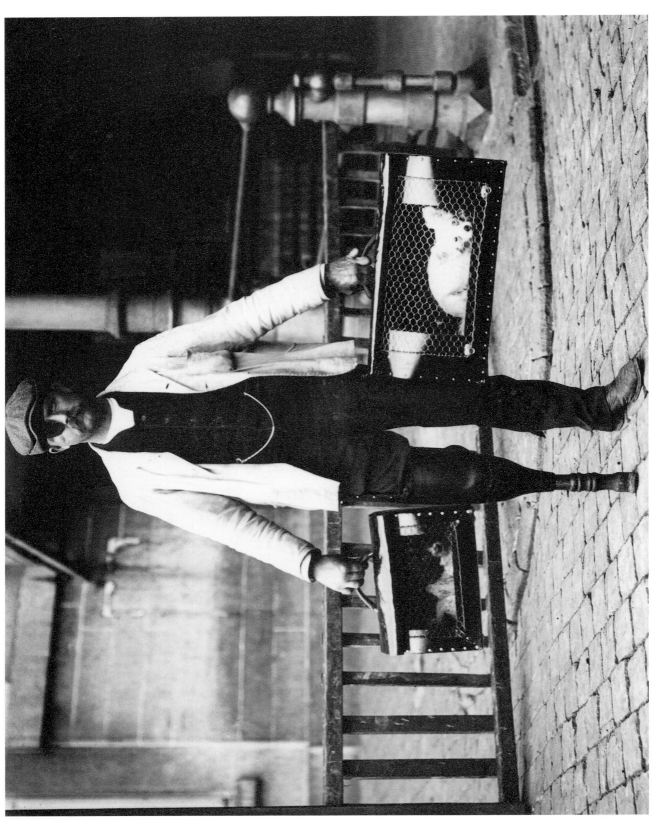

53. Paris dog market - The gatepost?

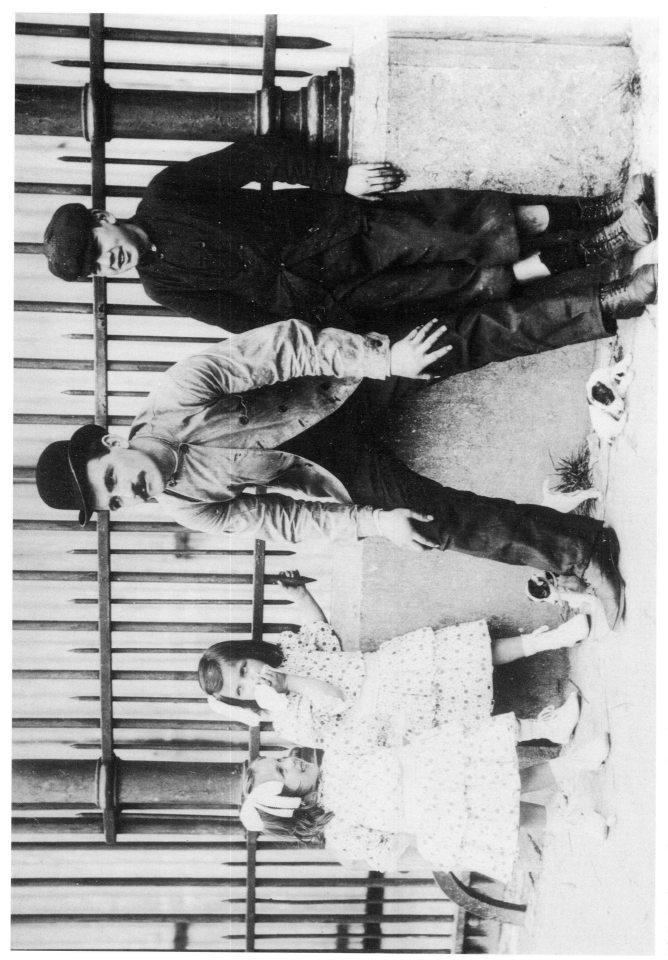

54. **Paris dog market** - Puppies for sale. The original print from which this is taken is held in the Victoria and Albert Museum collection.

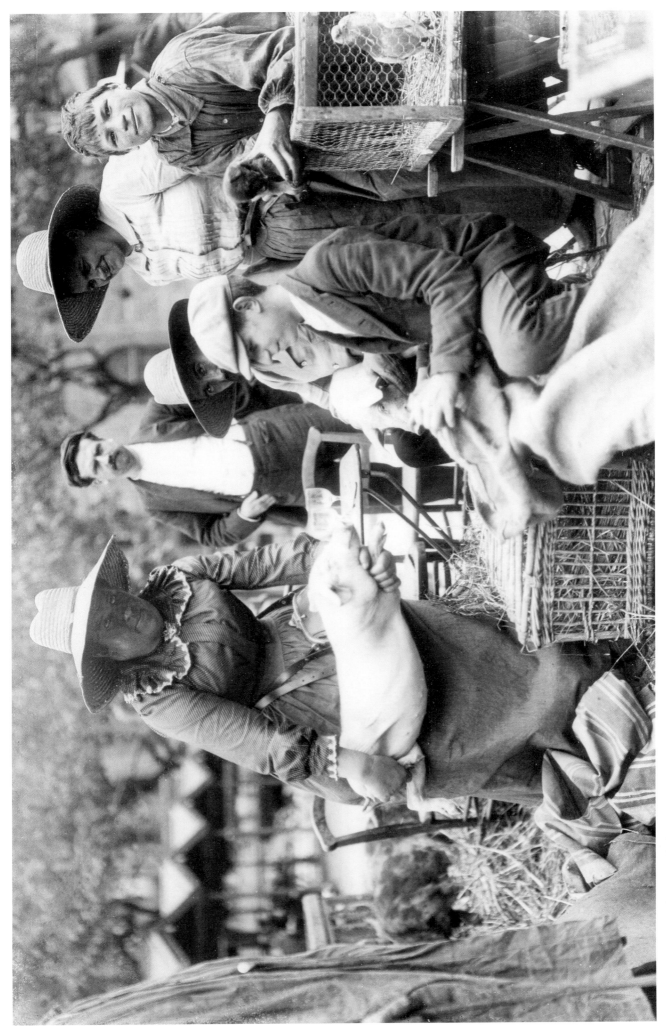

55. Paris animal market - Pig lady

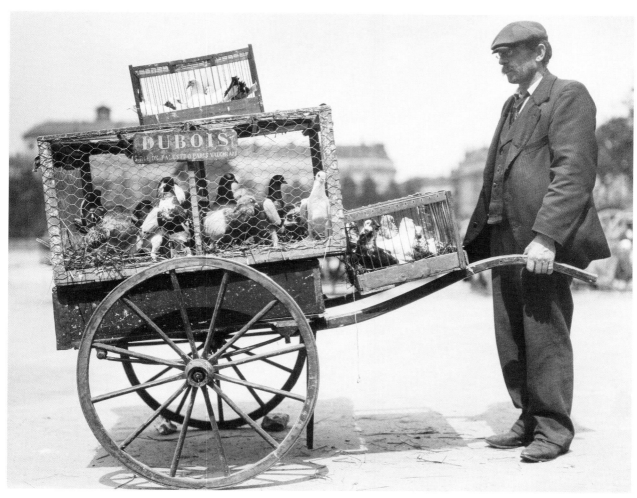

56. Paris bird market - Dubois

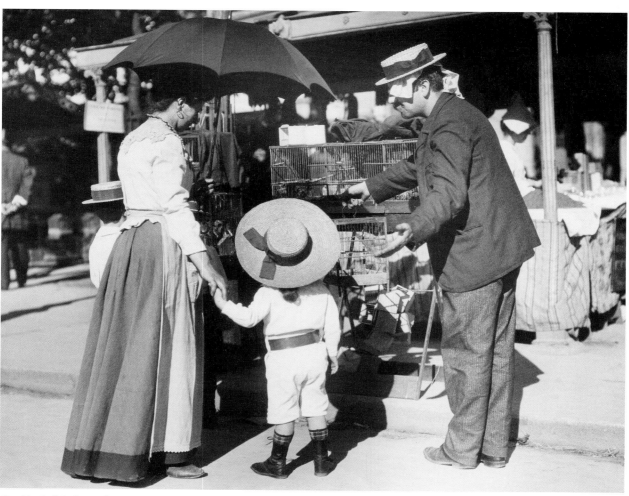

57. Paris bird market - Keen to buy

The February 1907 issue of *Wide World* magazine contained a six-page article 'The Sea Hedgehog Harvest.' *An interesting description of a quaint industry which very few people have ever heard of - the capture and sale of the 'Sea Hedgehog'. By A. Pitcairn-Knowles. Photographs by the Author.*

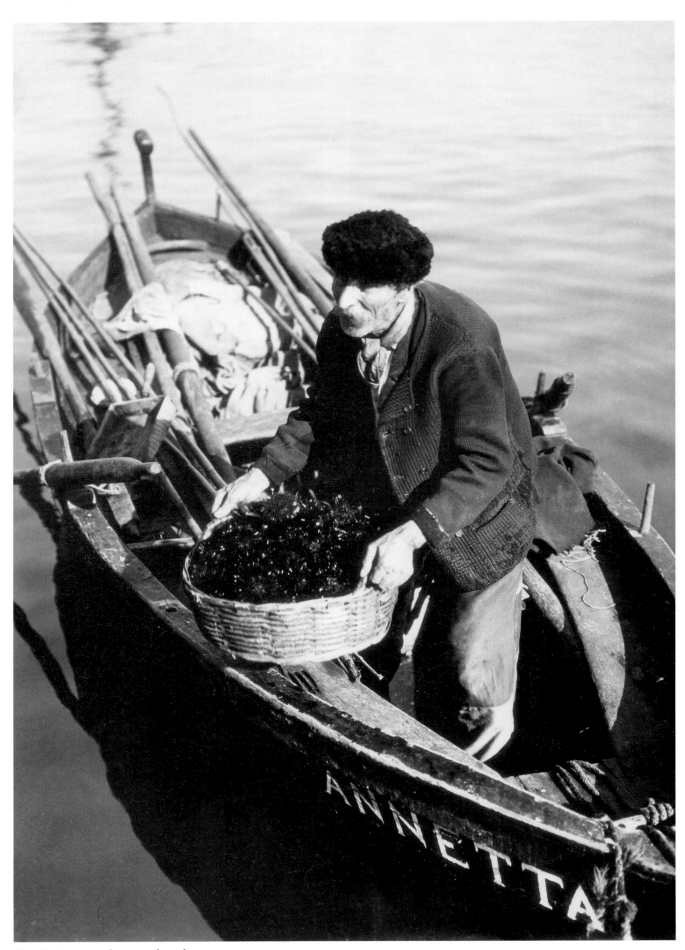

58. Bringing the catch ashore

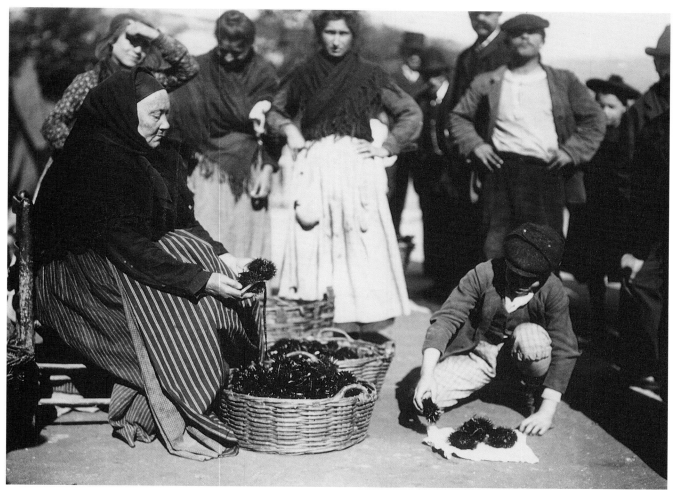

59. A scene in the Sea Hedgehog market

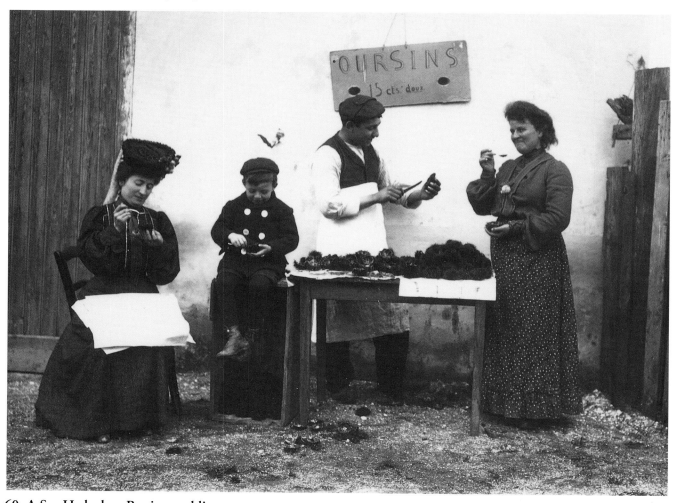

60. A Sea Hedgehog Bar in a public street

Ostend Races in May 1908 – 'How the Belgian bets or where the bookmakers and the *Paris Mutuel* work side by side and prosper' P.K's writing on envelope containing original prints.

61. From the horse's mouth?

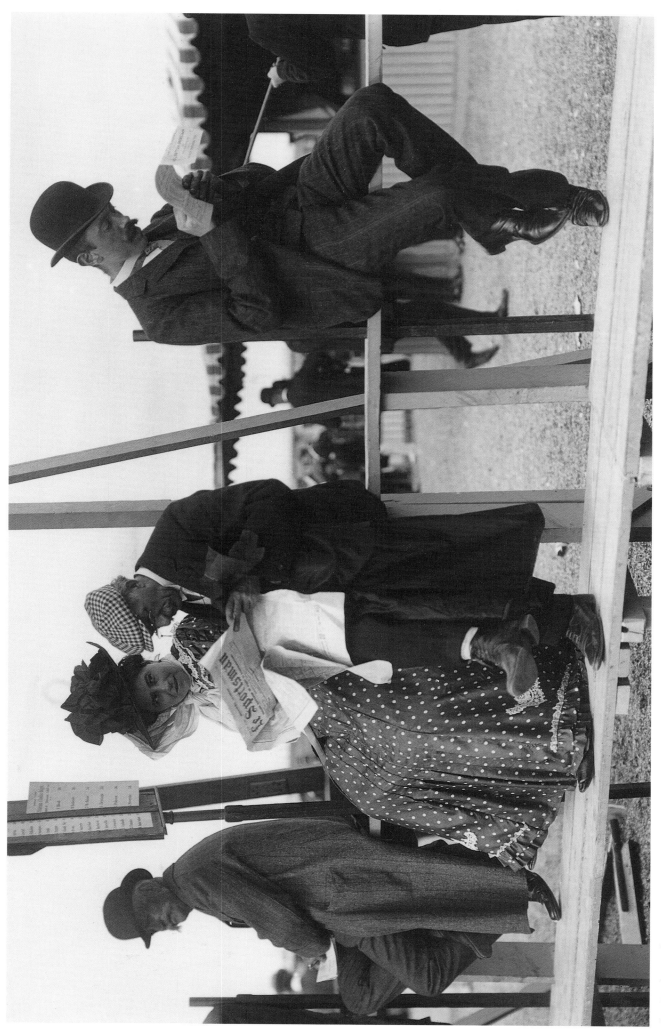

62. Studying form

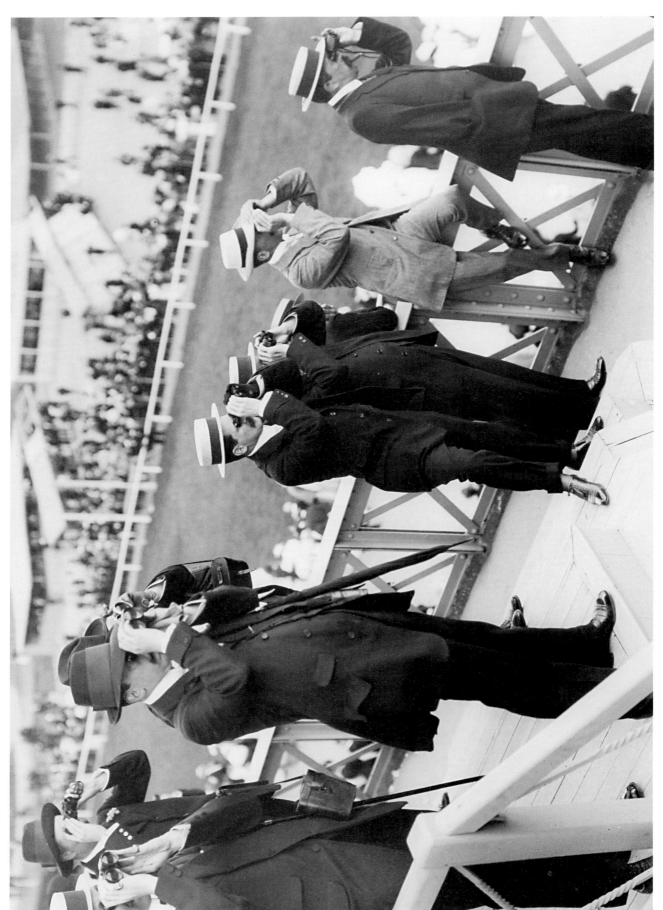

63. My Fair Lady

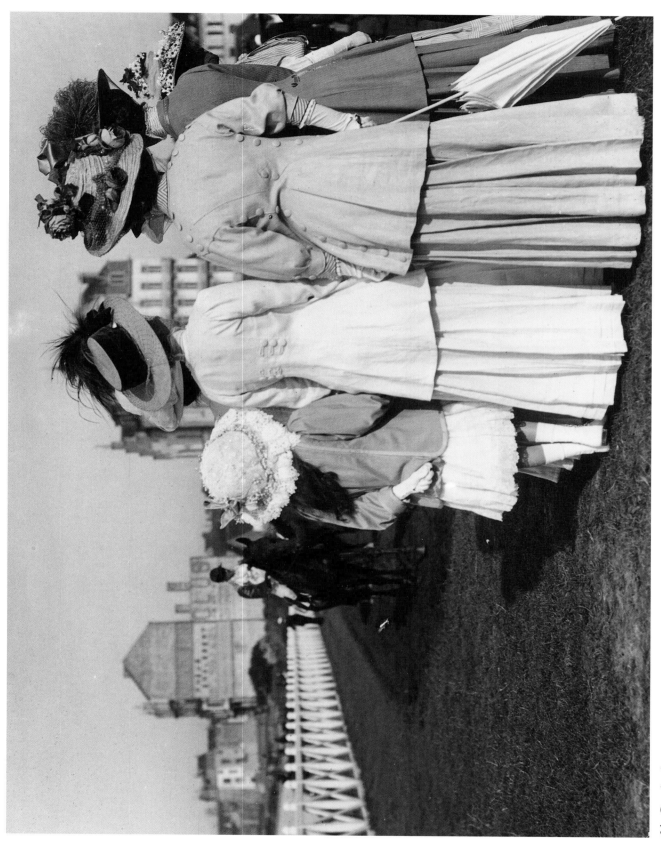

64. Gossipping

65. Plant Shelters – Patterns created by these vast areas for protection 'a hundred years before polythene', attracted P.K's lens, and 16 glass negatives were in the box marked *Pflanzenschutz.*.

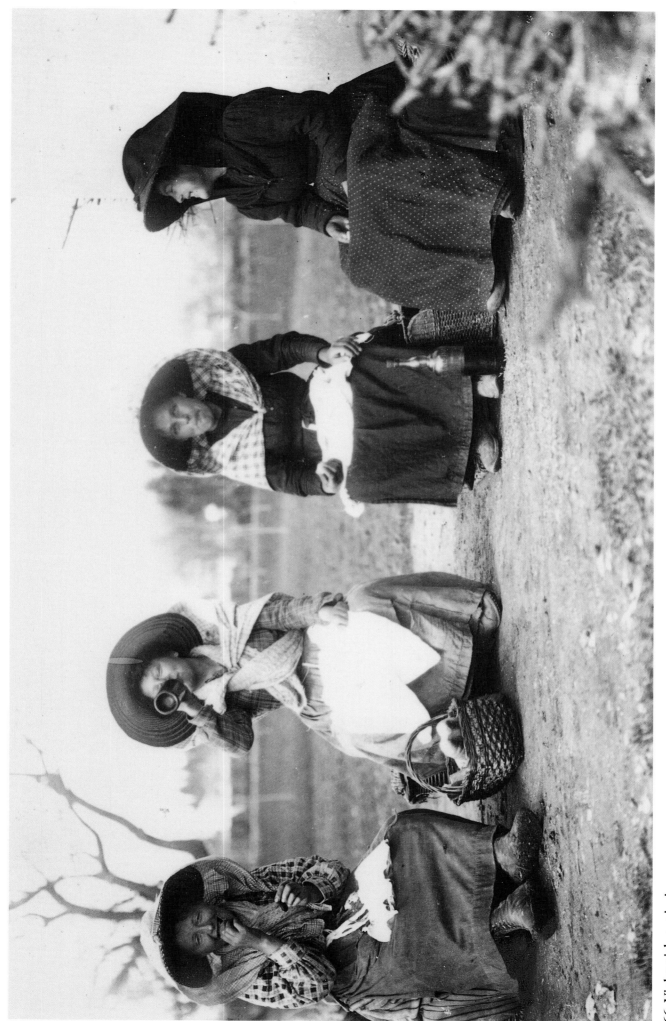

66. Violet pickers picnic

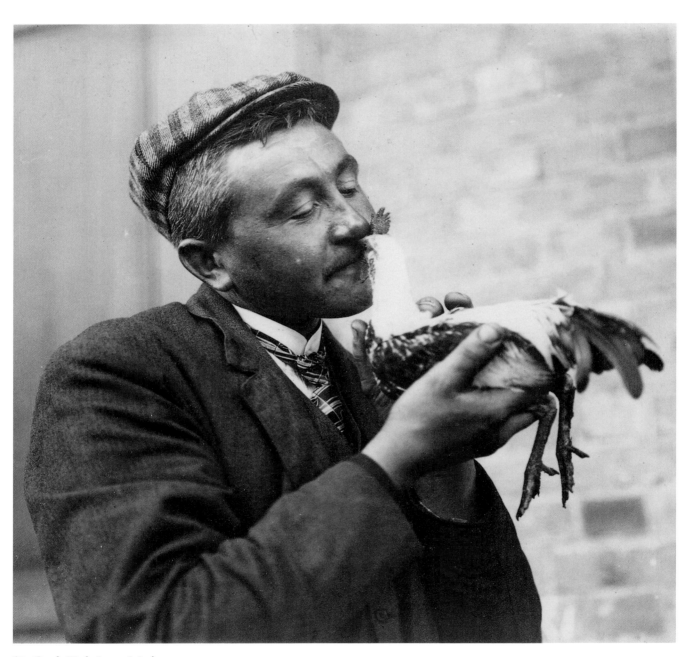

67. Cock Fighting - My beauty

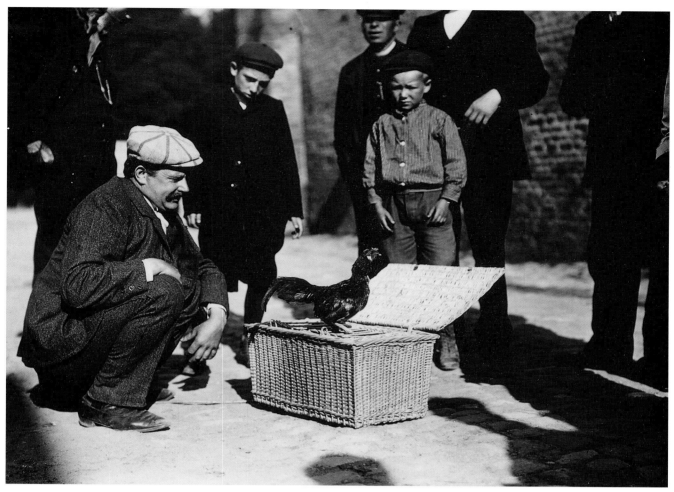

68. Another prize beauty

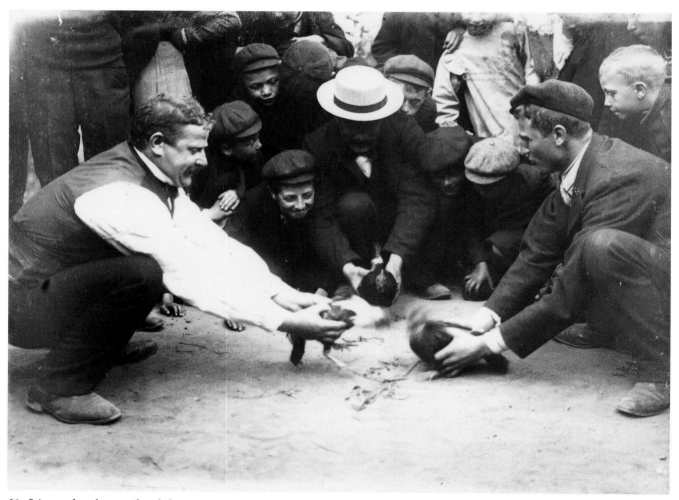

69. It's not legal now thank heavens

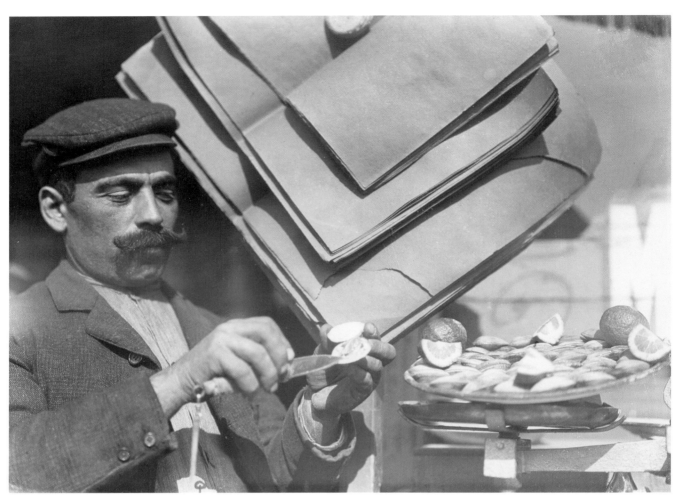

70. Cockles - Paper bags

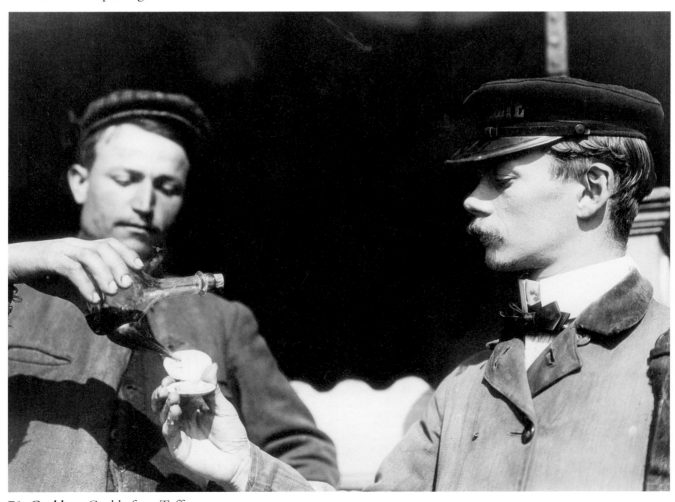

71. Cockles - Cockle for a Toff

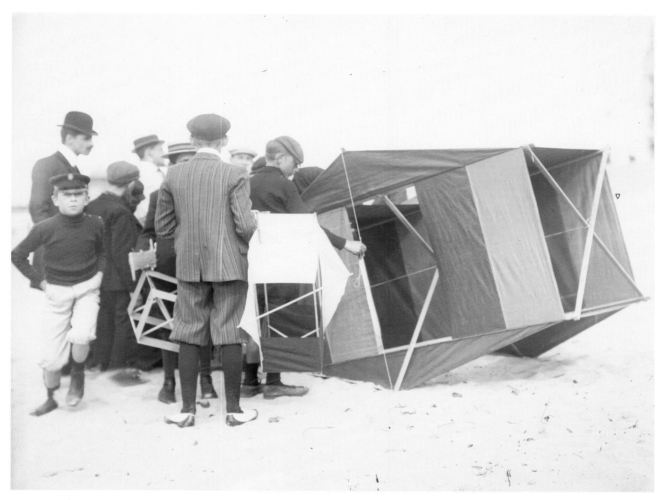

72. Kite Flying - Ostend. Enormous box-kite

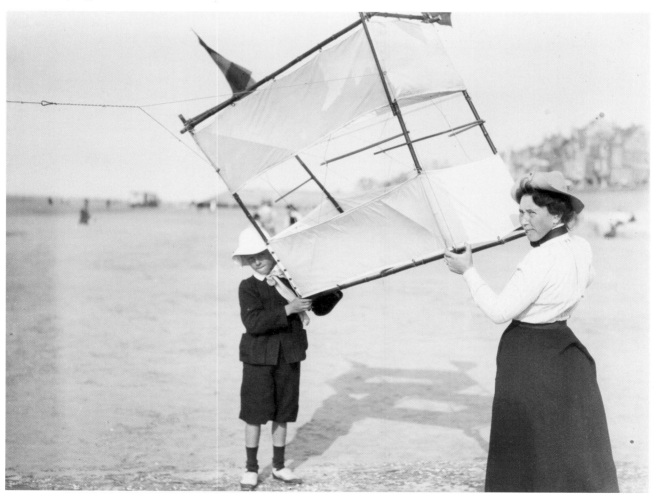

73. Kite Flying - Ready to launch

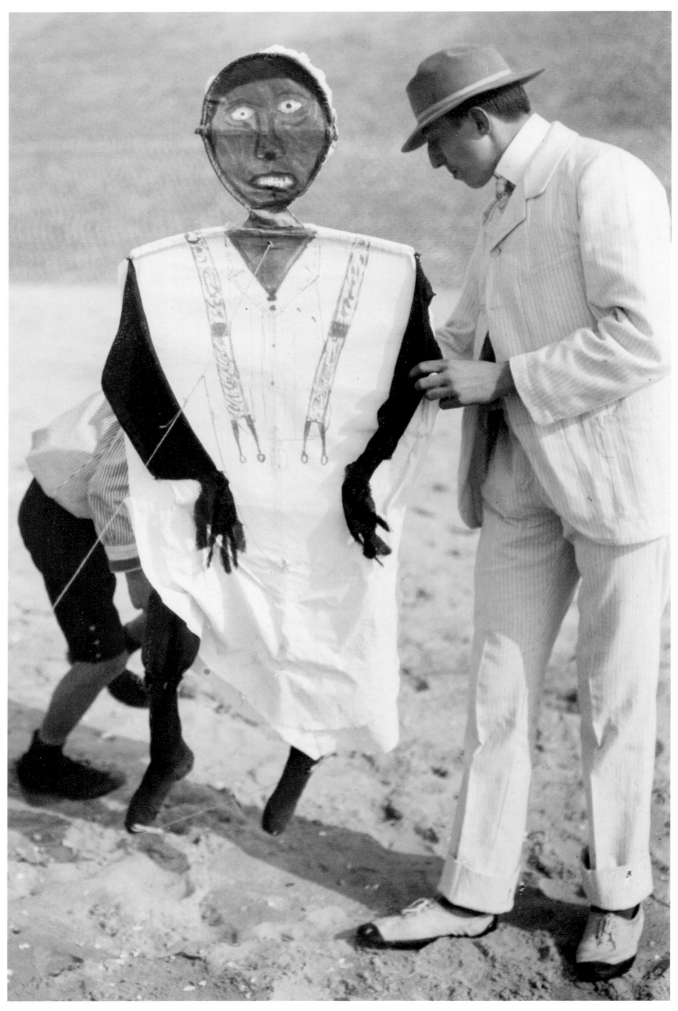

74. Kite Flying - Will he fly?

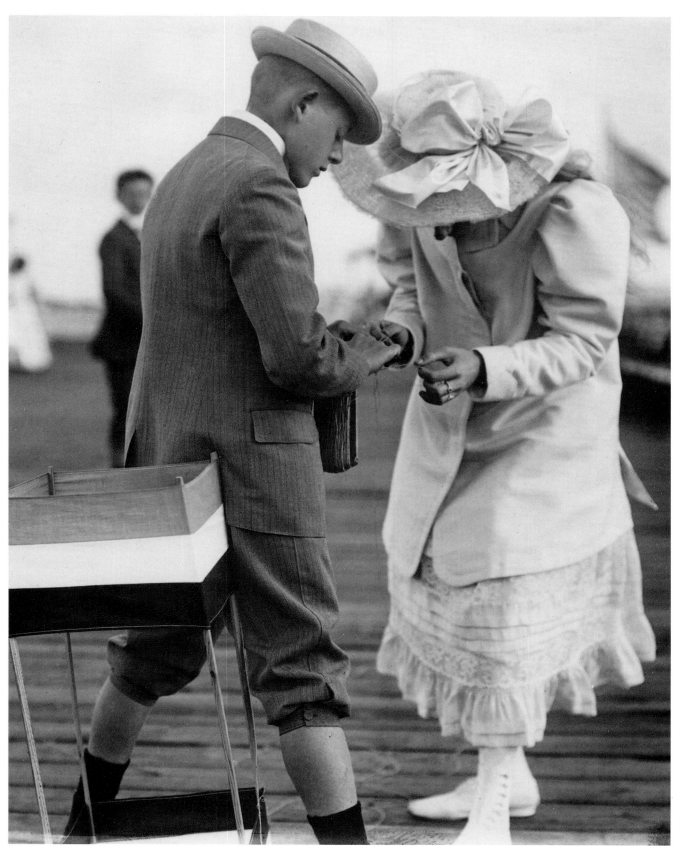

75. Kite Flying - Knots?

76. Heap of dried seaweed

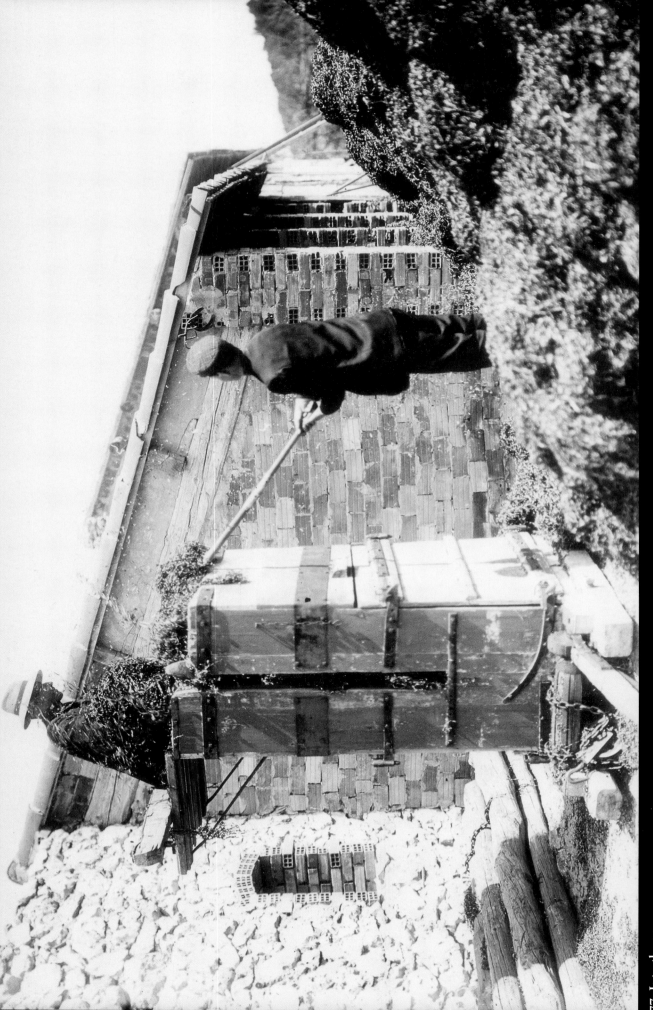

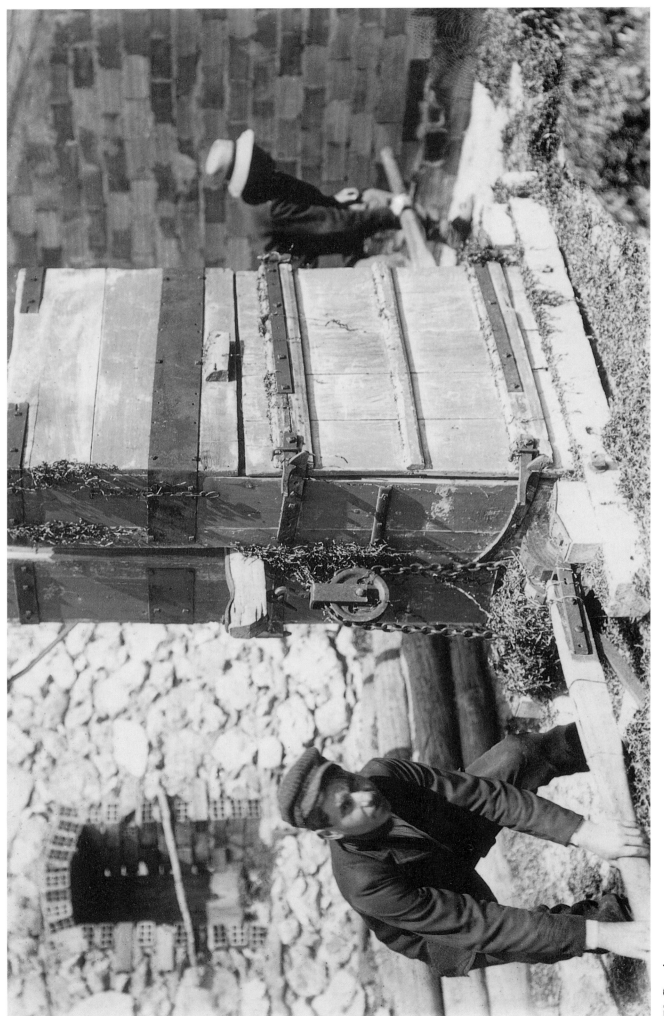

78. Pressing

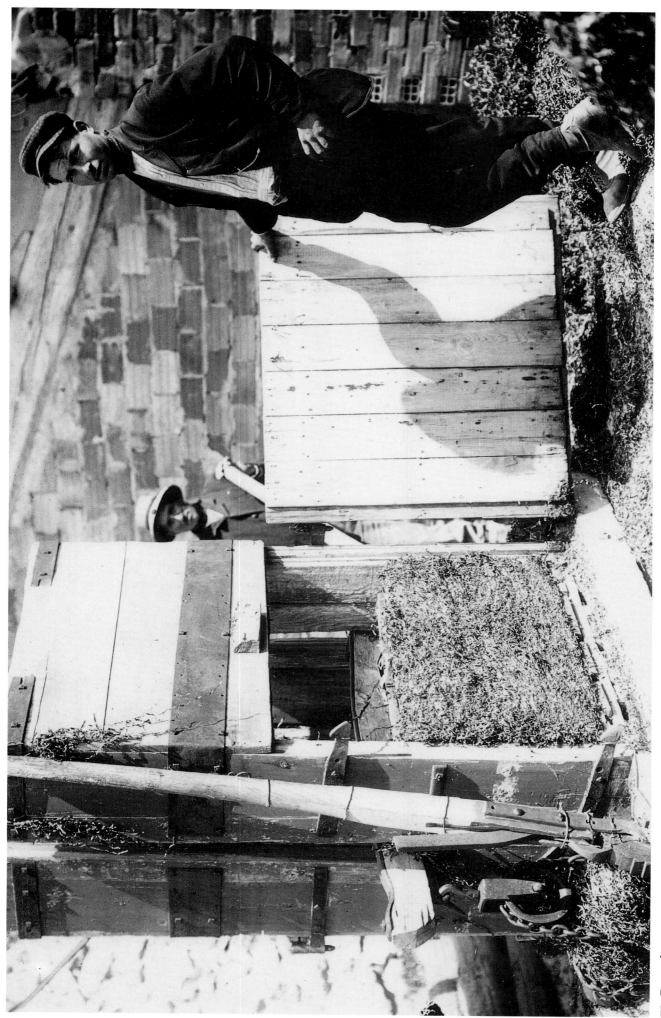

79. Pressed

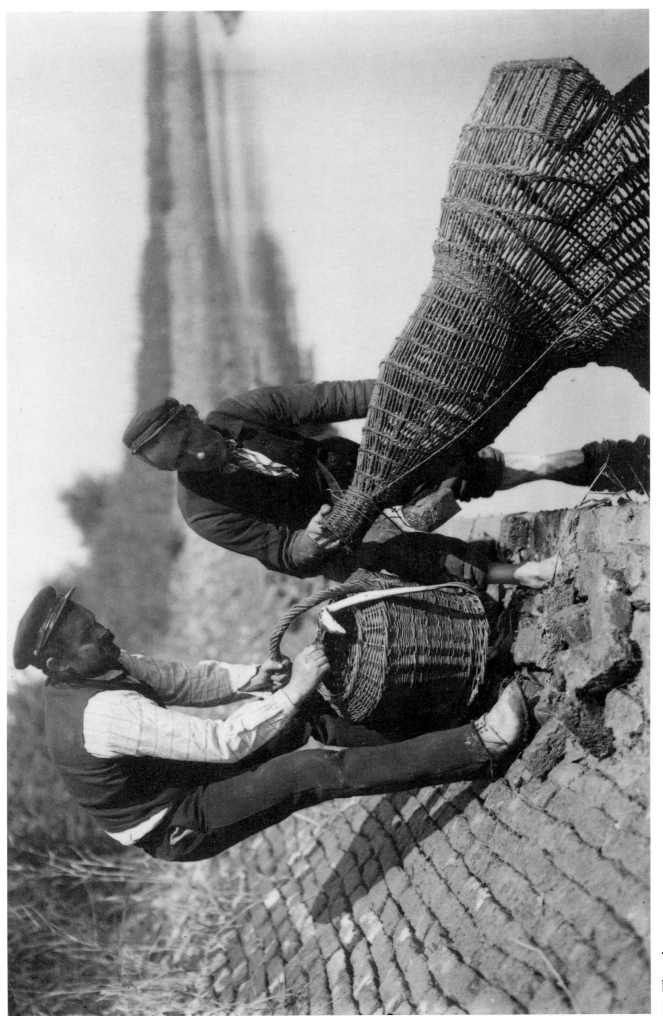

80. The eel trap

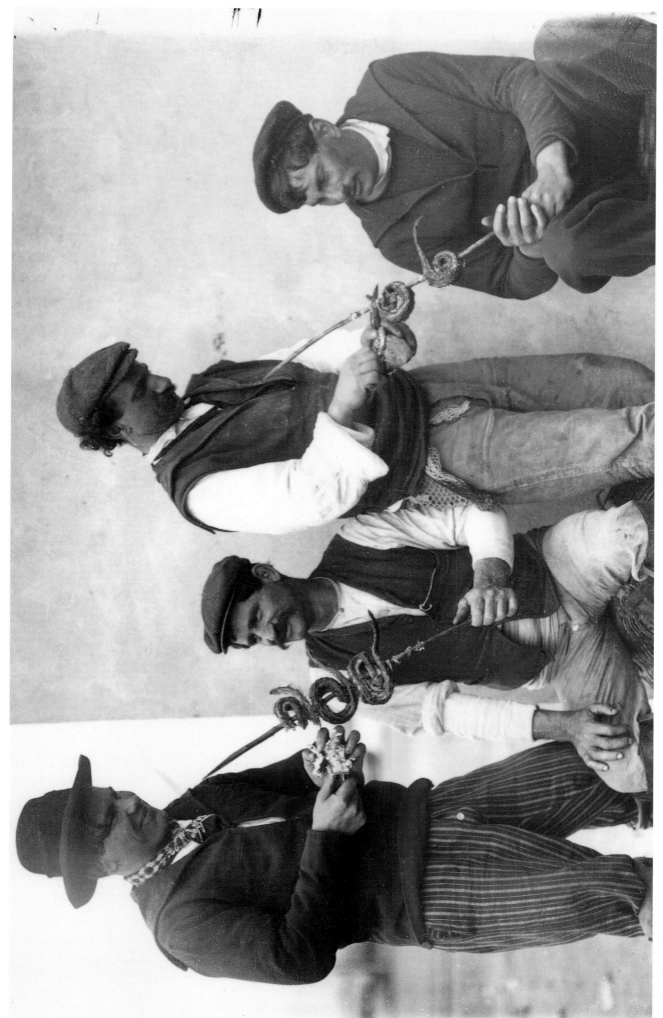

81. Smoking the eels

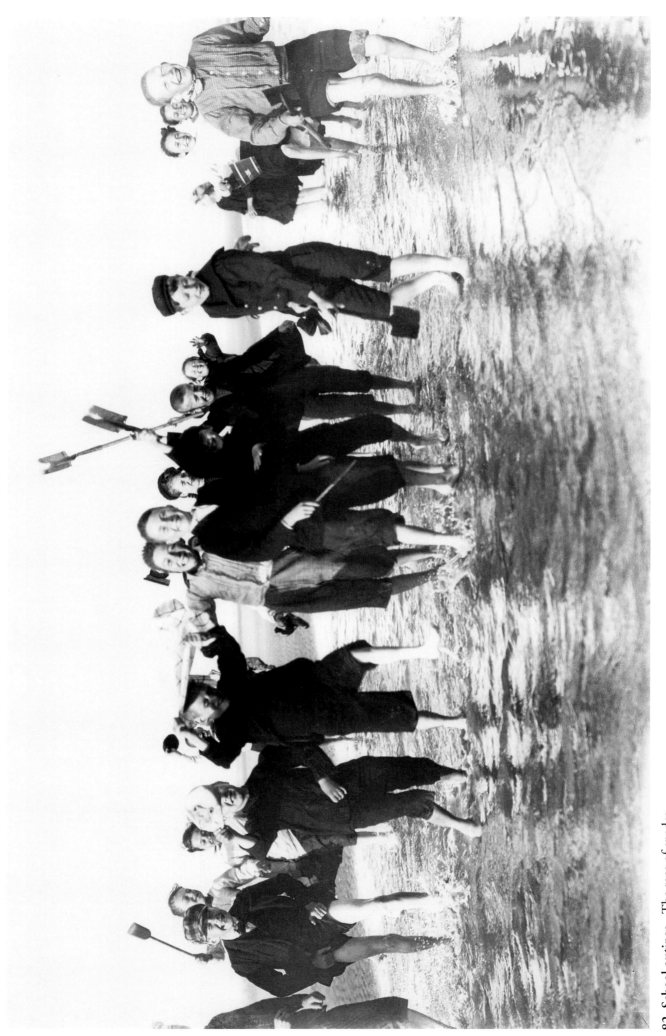

82. School outings - The race of spades

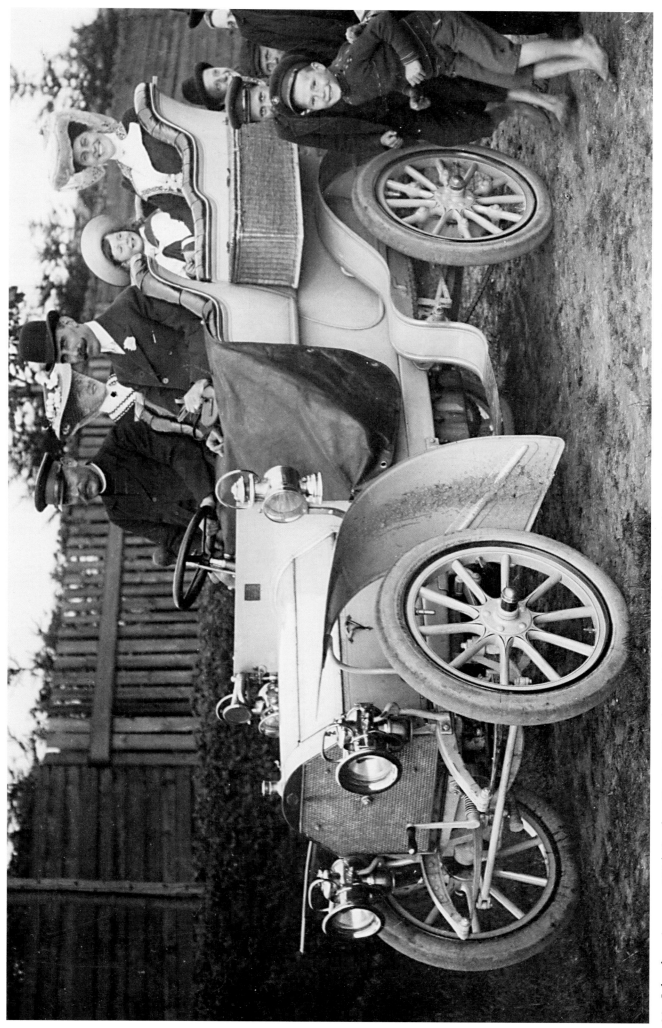

83. School outings - c 1904 Gordon Pitcairn-Knowles, aged about 4, with long hair, his mother, aunt and uncle, with onlookers!

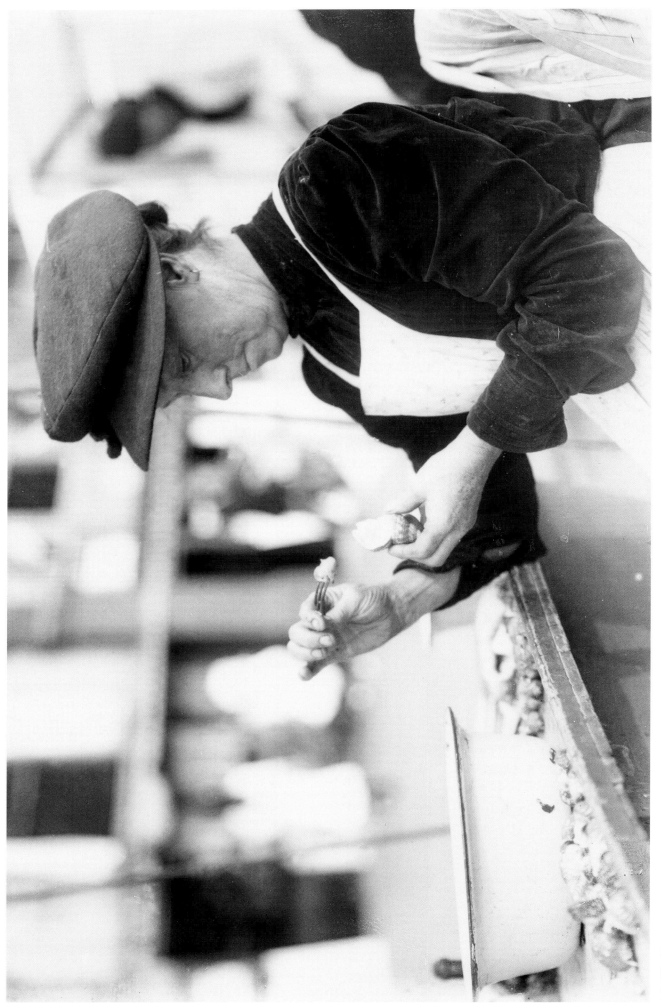

84. Winkles

Watching the Derby - early 20th century Epsom Downs vantage points

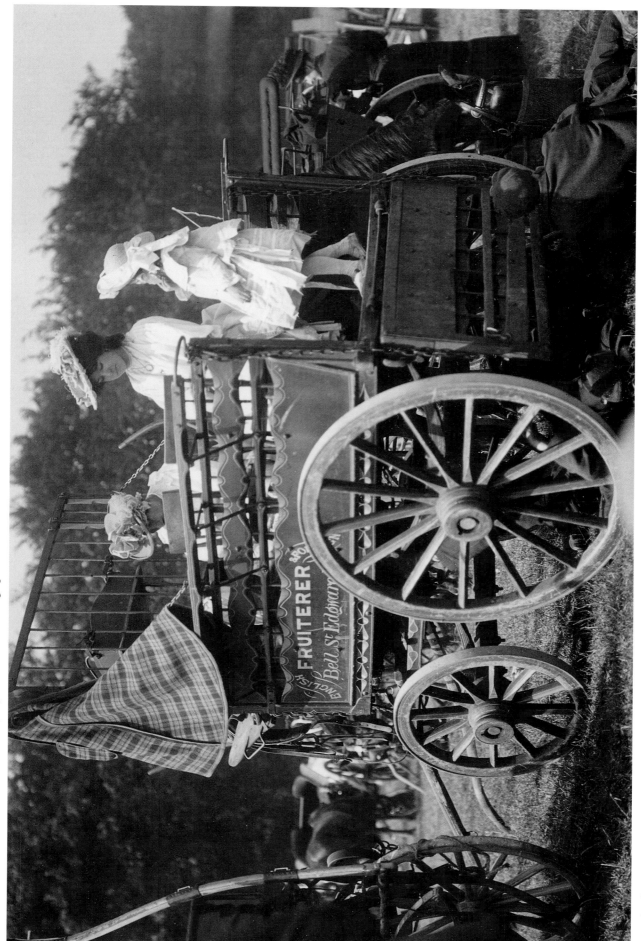

85. The fruiterer

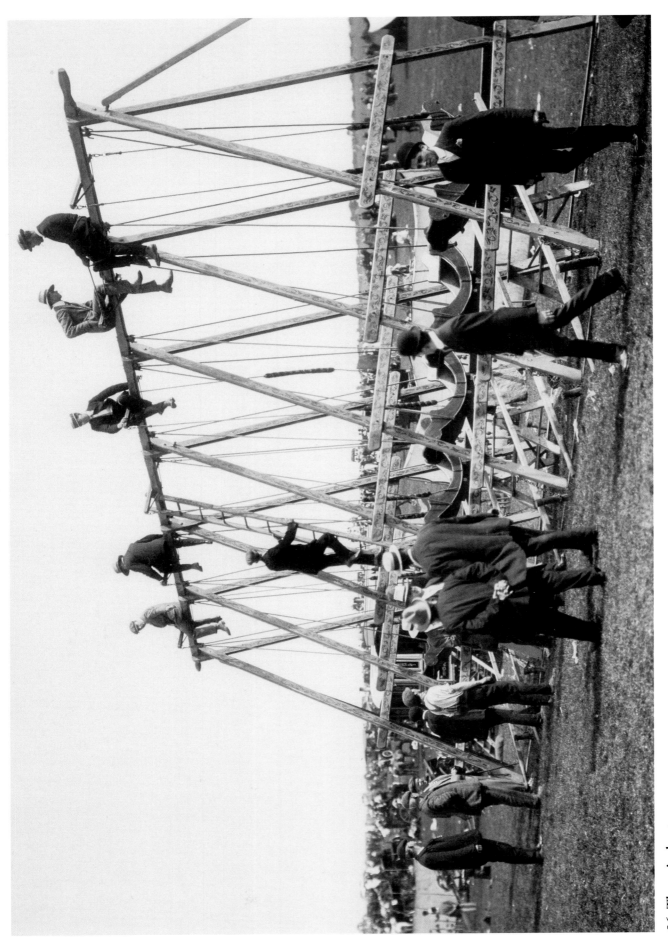

86. The swingboats

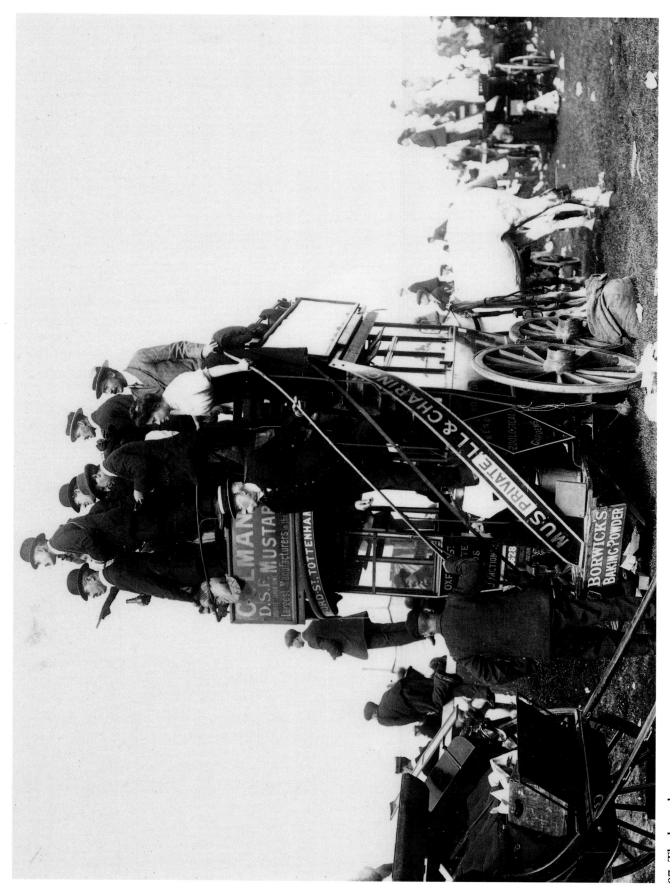

87. The horse bus

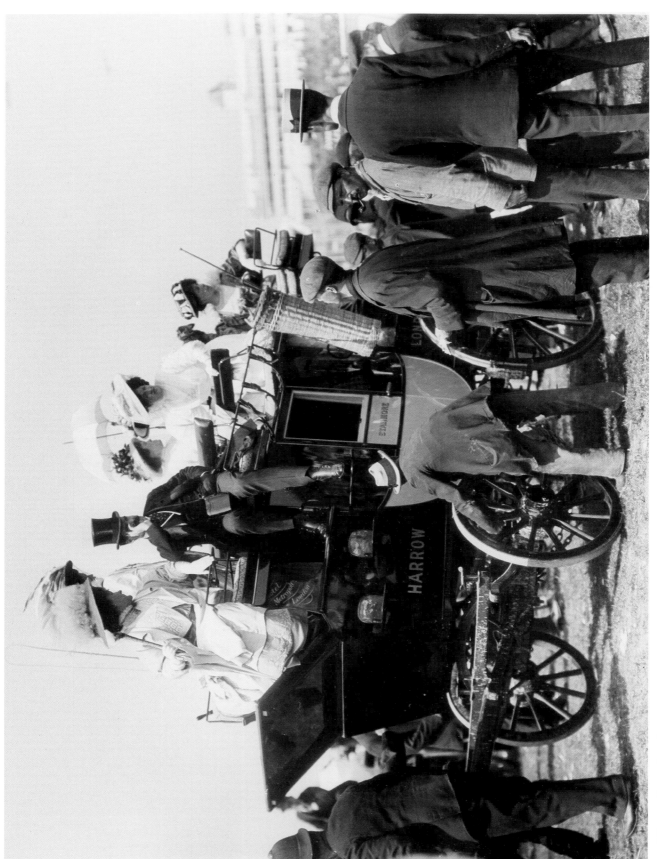

88. The mail coach - above stairs

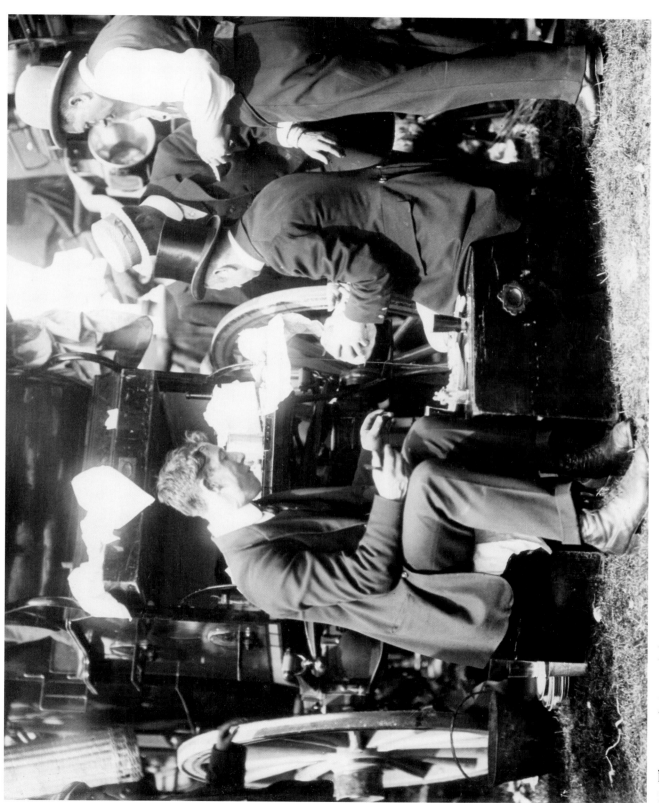

89. The grooms' picnic - below stairs

This article must have been one of the last, if not the last, of P.K's articles for *Wide World* magazine, issued in May 1924, 12 years after his energies had been transferred to the development of the Riposo Nature Cure Hydro at Hastings, Sussex.

'Winter wildfowling in Friesland by A. Pitcairn-Knowles' was a seven-page article containing eleven of his photographs.

'On the vast stretches of frozen water which in winter time fringe the desolate shores of Northern Holland the fearless, venturesome Friesian wild-fowlers snatch a living by shooting the geese, duck, and other wild migrants that hunt the ice fields. It is a hard life – how hard only those who have seen the men at work can realise.'

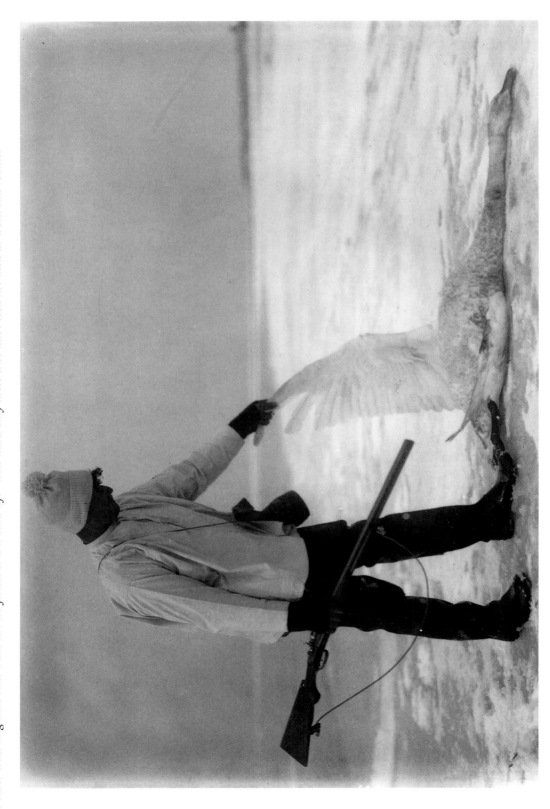

90. A beautiful wing

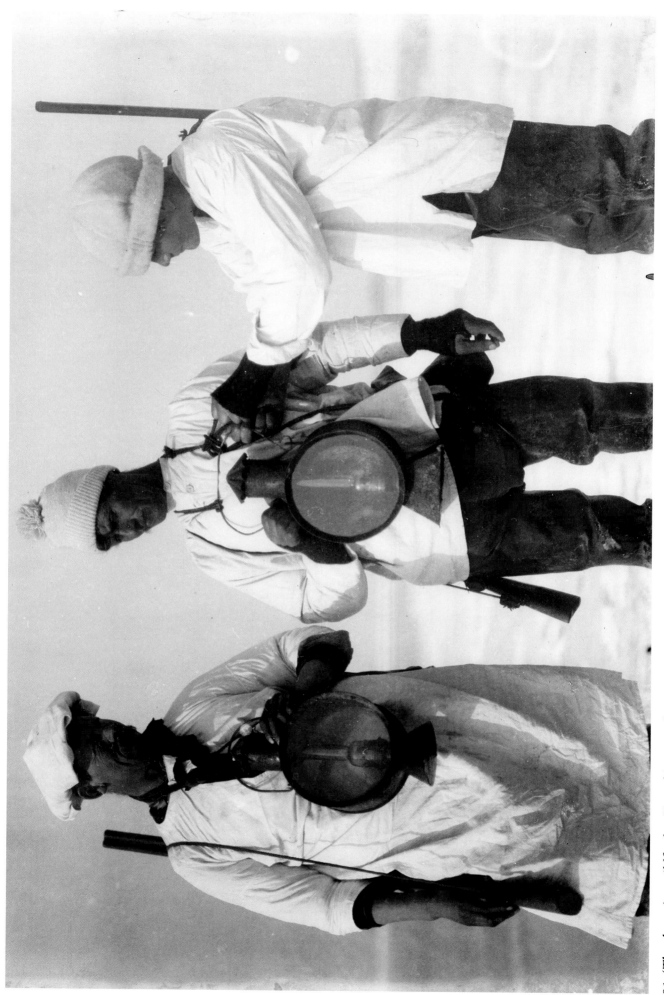

91. 'The champion wildfowler, Kooy, his son and a companion'

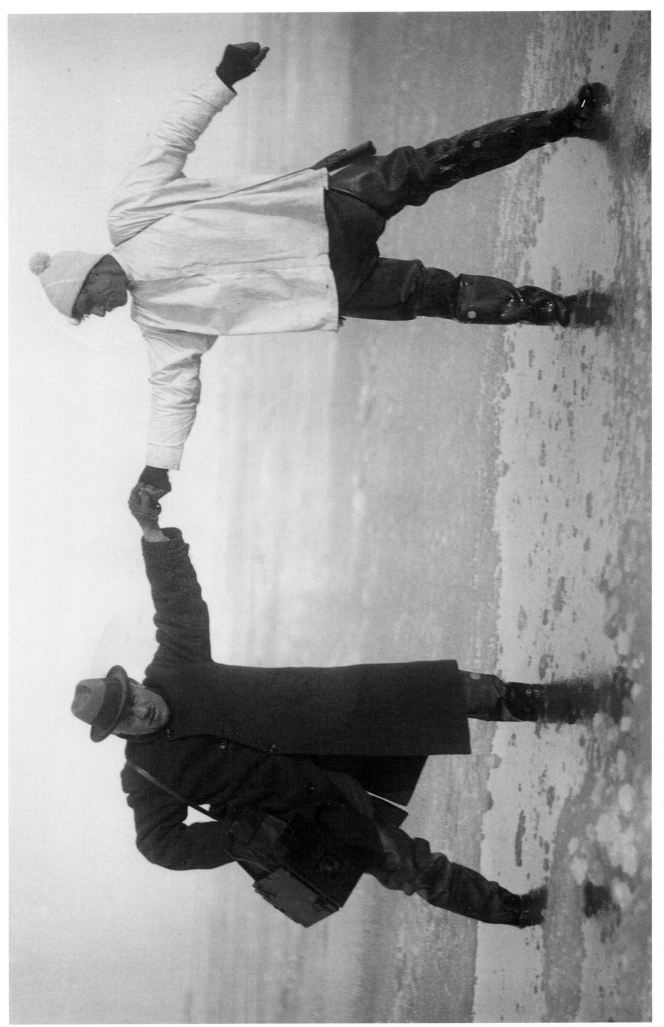

92. 'The Author in trouble on the ice field a mile from shore'

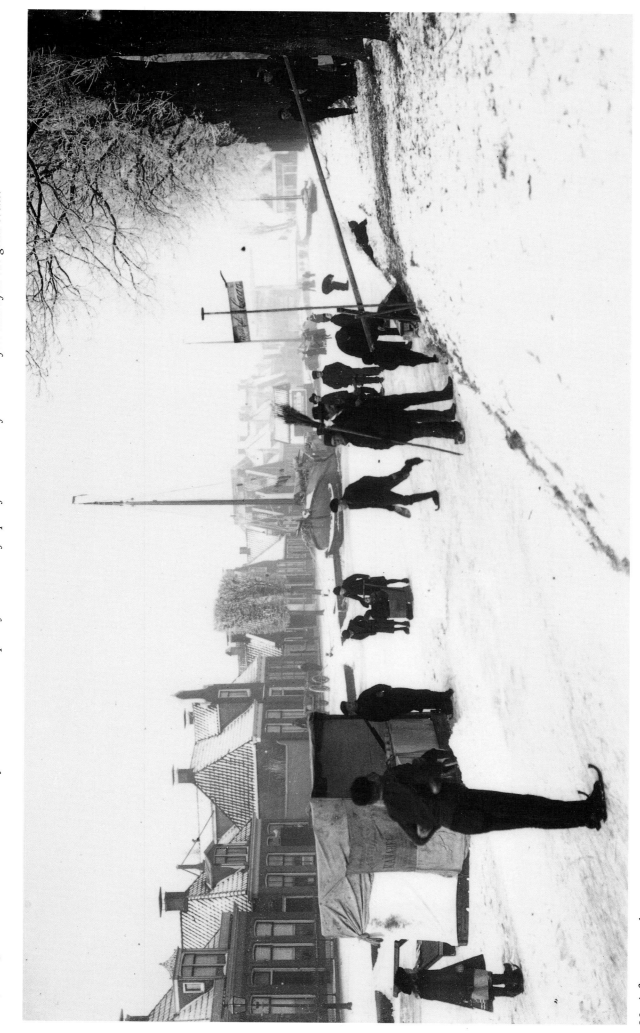

'Through Friesland on skates' *Wide World* magazine, December 1906.
'Every village has its own race track and everywhere the canal ice-sports form the chief topic of conversation for weeks before and after the great event.'

93. A frozen canal

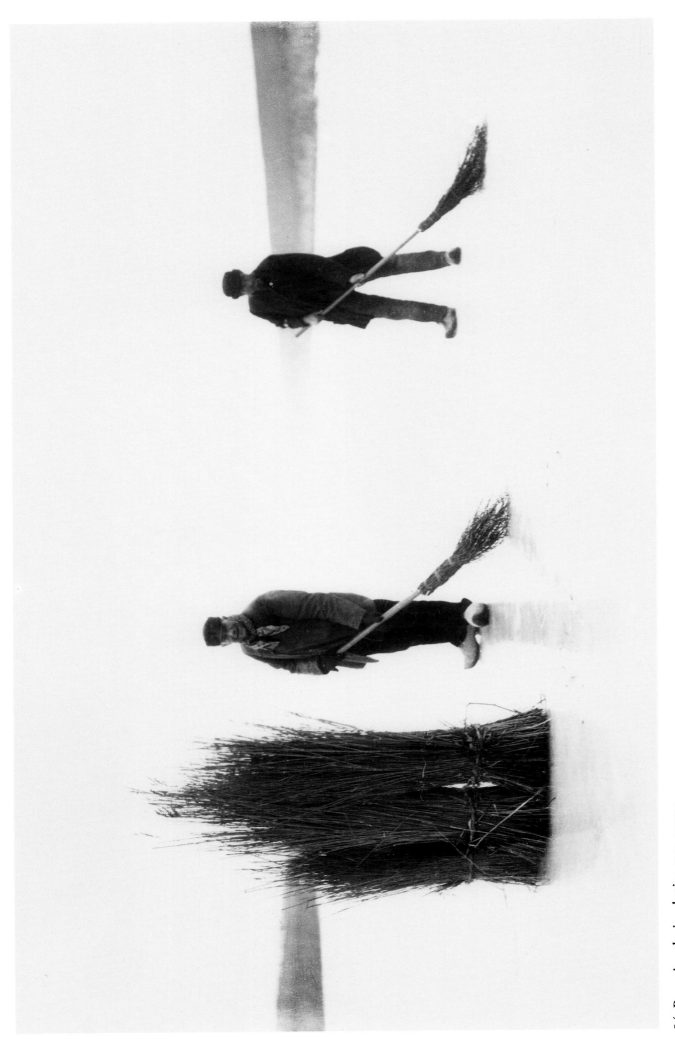

94. Preparing the ice skating race course

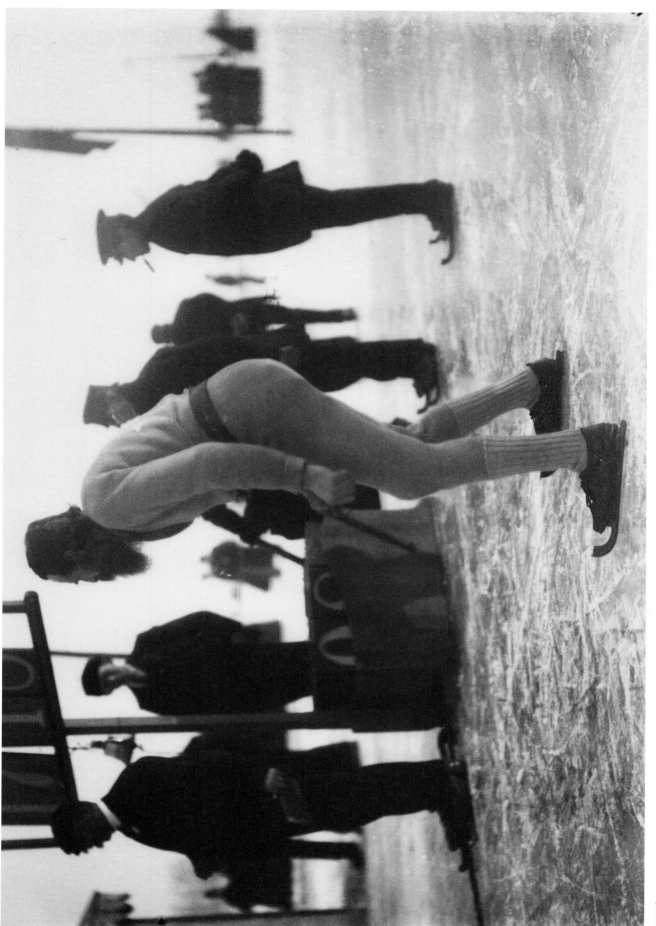

95. The veterans' start

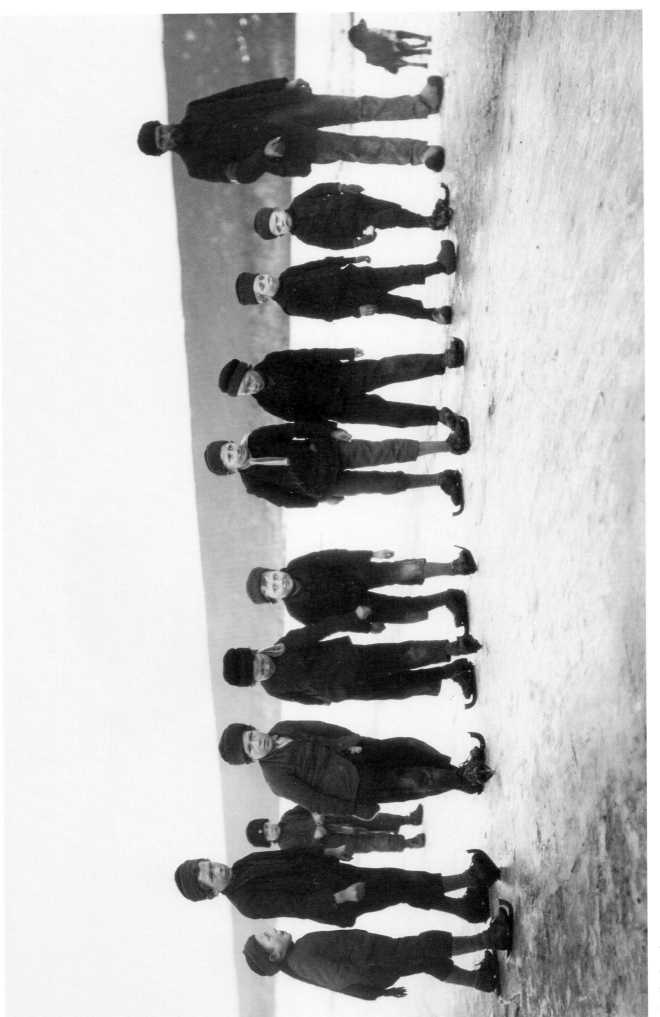

96. The boys' start

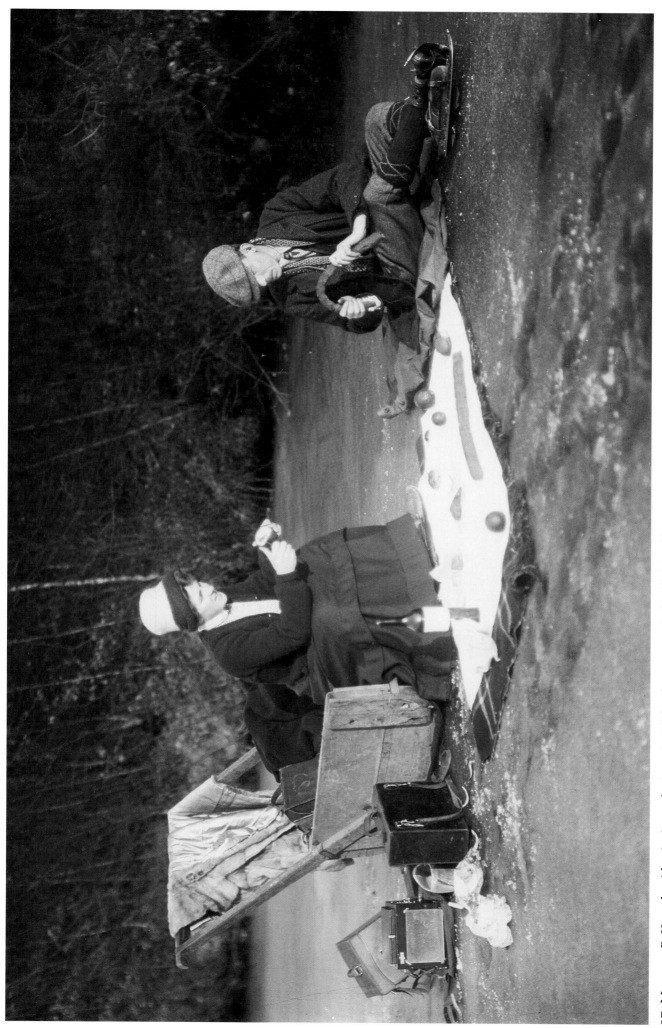

97. Margaret P.-K. and guide picnic on the ice - A. P.-K's other cameras lie beside his wife.

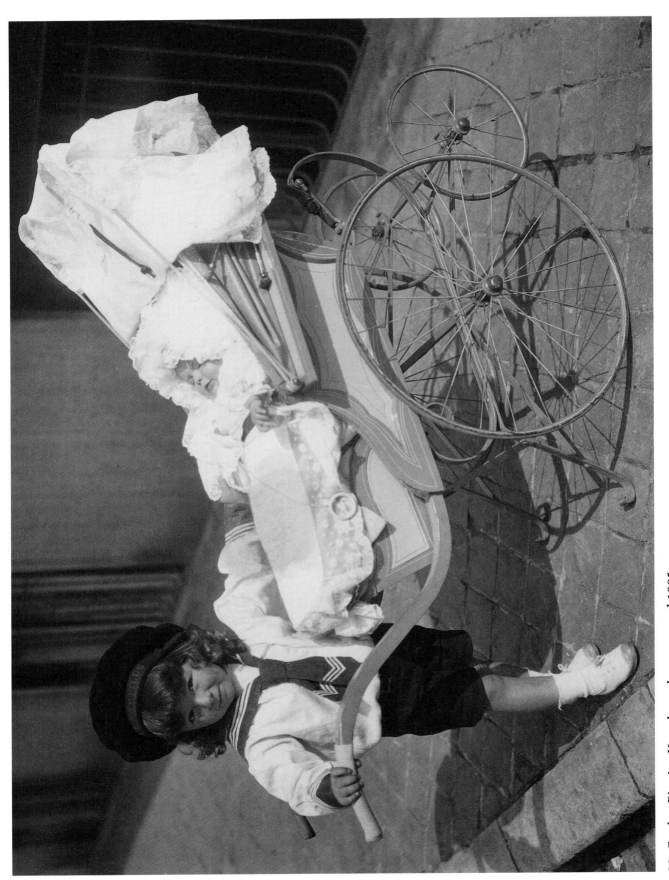

98. Gordon Pitcairn-Knowles and pram around 1905

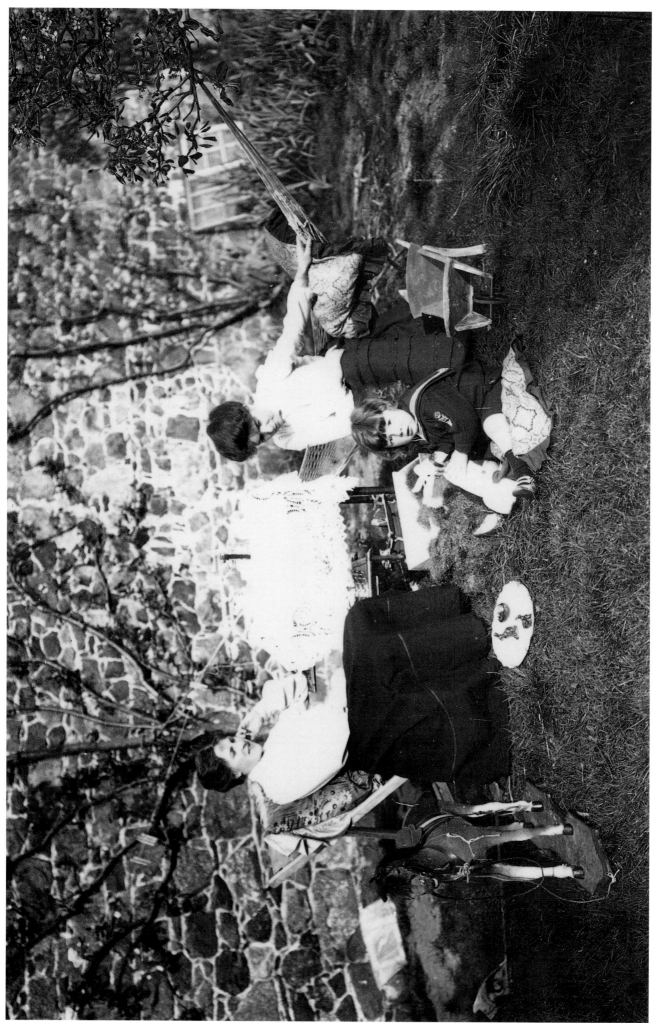

99. Gordon Pitcairn-Knowles, his mother and aunt, Jersey

100. Gordon Pitcairn-Knowles playing naked Boule

At the Belgian seaside

101. Minding the boots

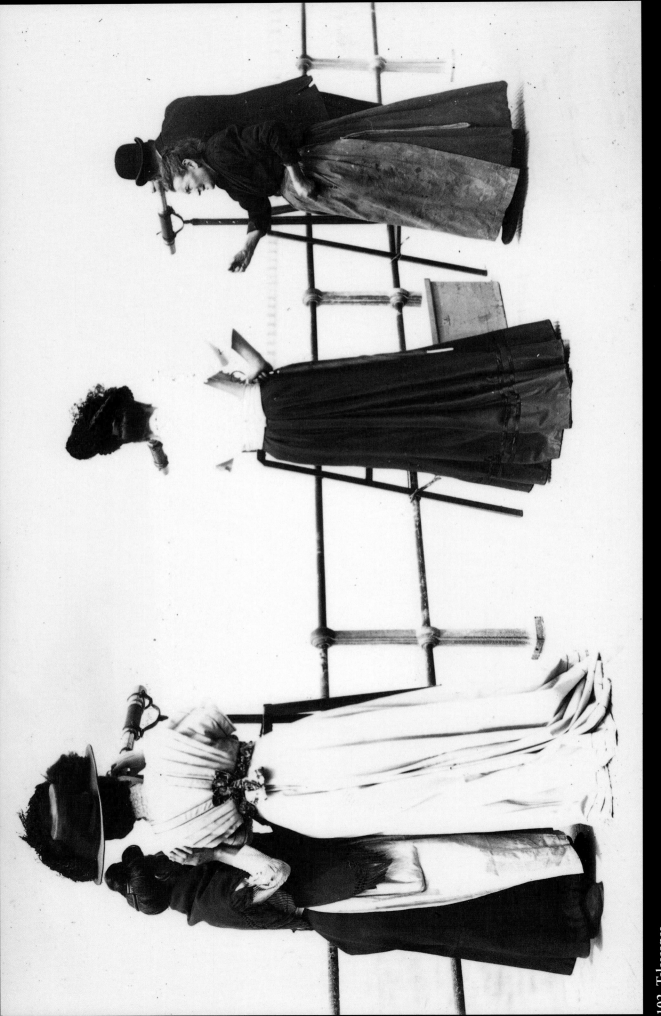

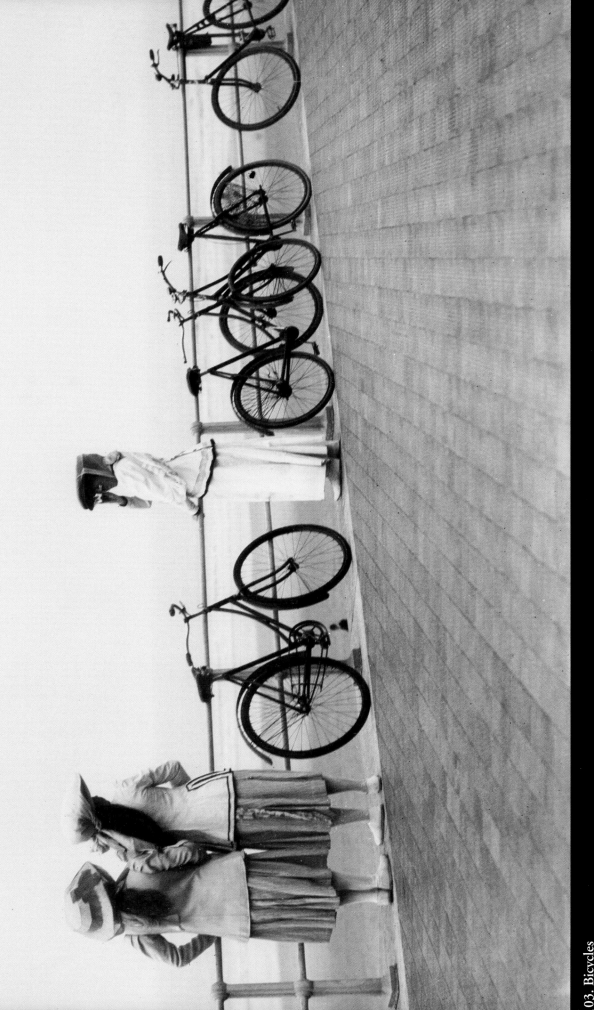

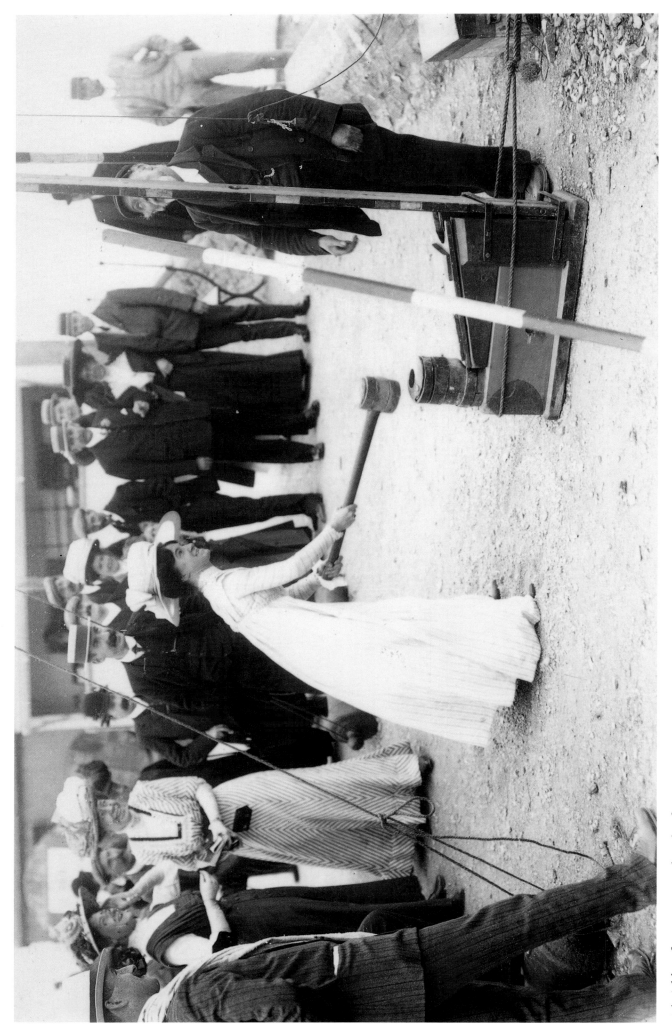

104. A blow for woman on the Isle of Man

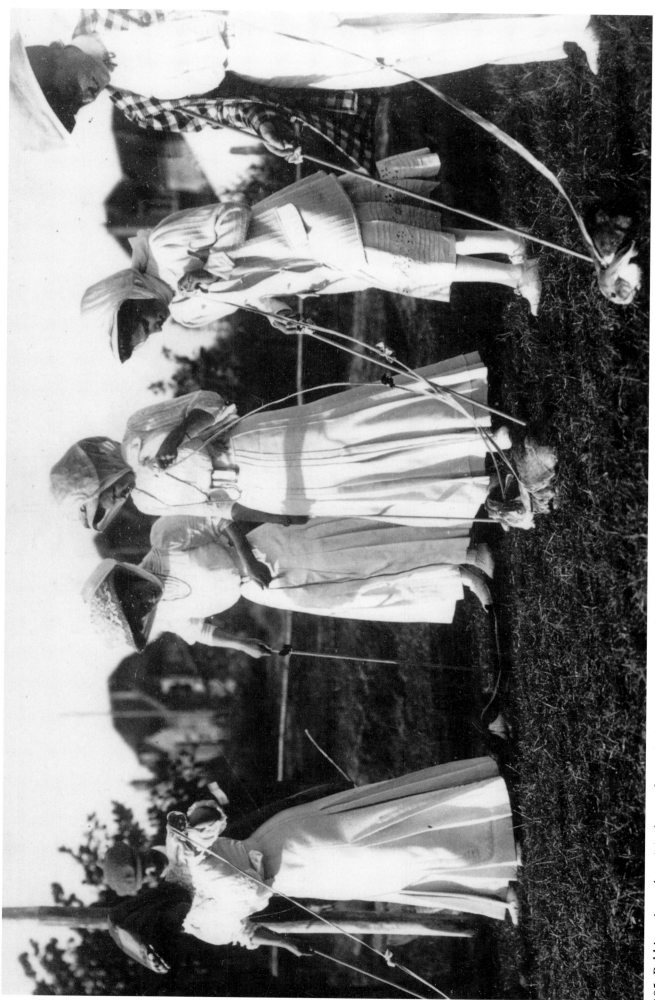

105. **Rabbit racing** - the original print from which this is taken is in the Victoria and Albert Museum collection

"**A school for fishing** by A. Pitcairn-Knowles. *Finding 'bad times' prevalent in the fishing industry, certain far-seeing people in Belgium instituted investigations and discovered that the incompetence of the fisherfolk themselves was the prime cause of the depression. Forthwith it was decided to educate the fisherman for his calling like any other craftsman. The outcome of this decision is the interesting school here described. With photographs specially taken by the author*"

"*One hundred and forty boys are being trained at the Ostend Ecole de Peche under the director, priest Abbe Pype.*" *Wide World* magazine, March 1905.

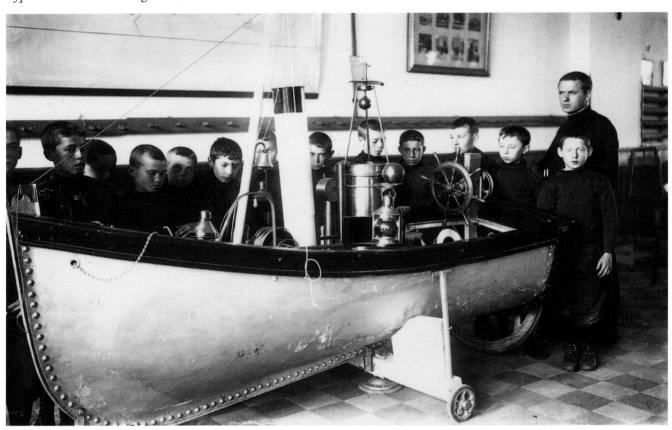

106. 'Instruction in handling marine engines forms part of the young fisherman's education'

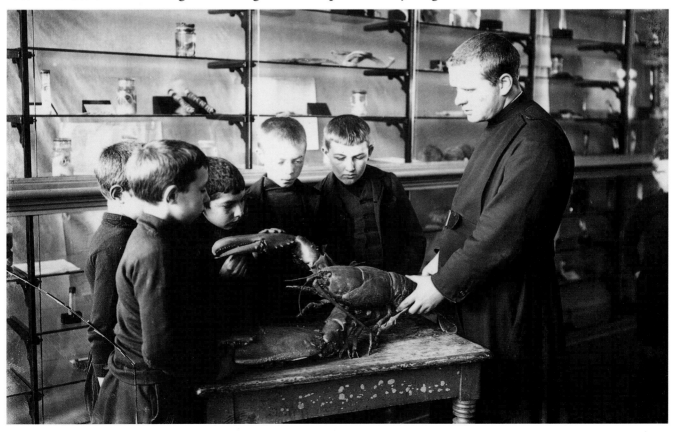

107. How to handle a lobster

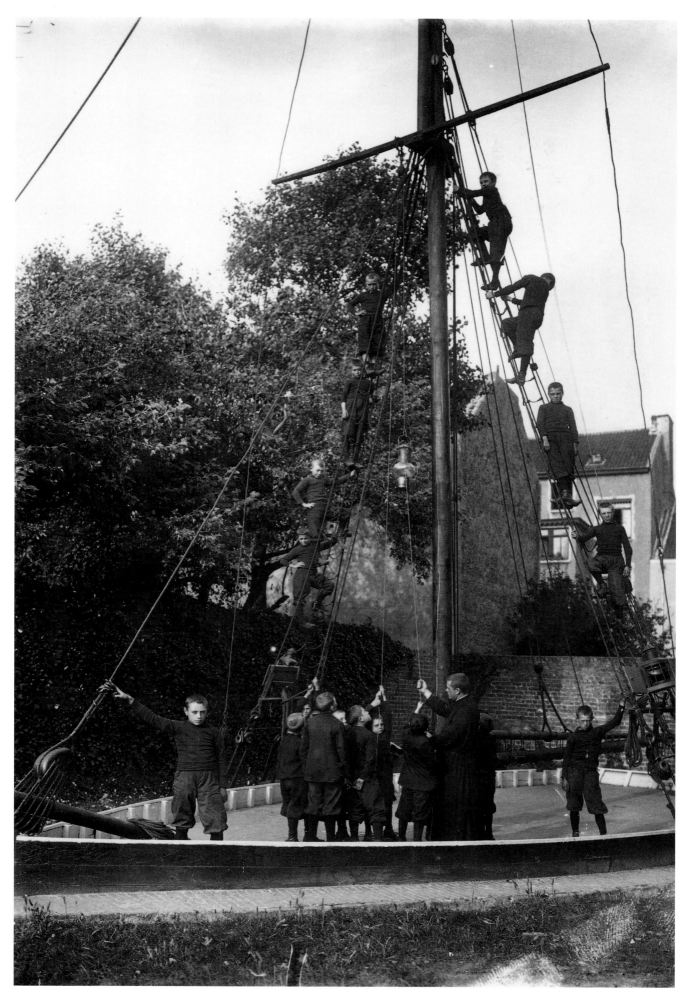

108. 'The full size model fishing boat in the grounds of the school'

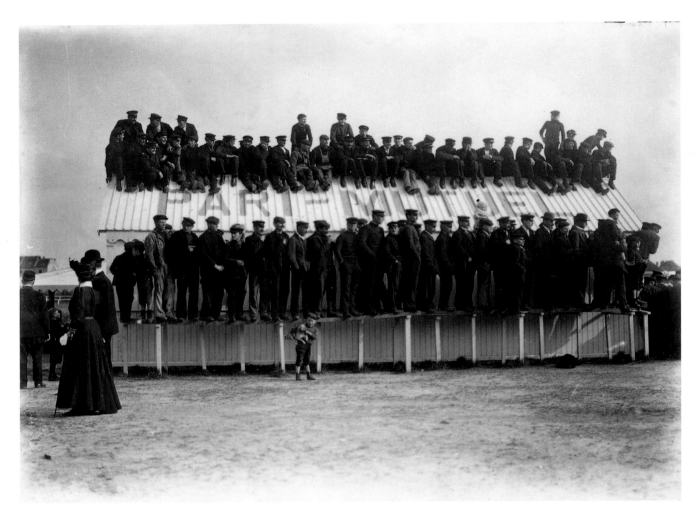

109. At the races - Ostend? c1900. On the Paris-Mutuel (Tote) roof.

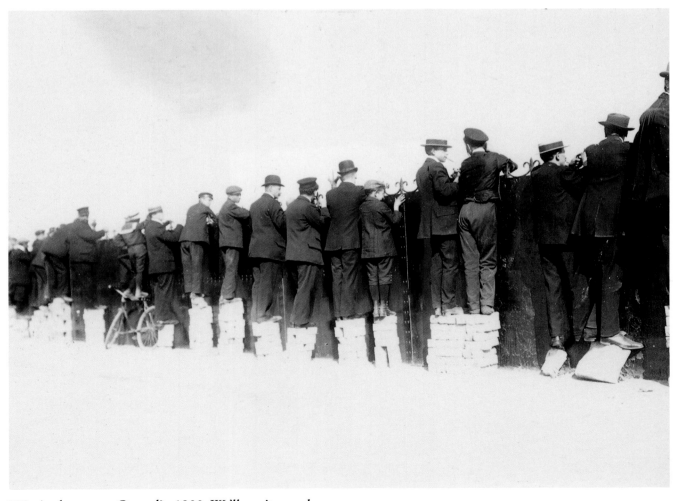

110. At the races - Ostend? c1900. We'll see it somehow